INDIAN ART

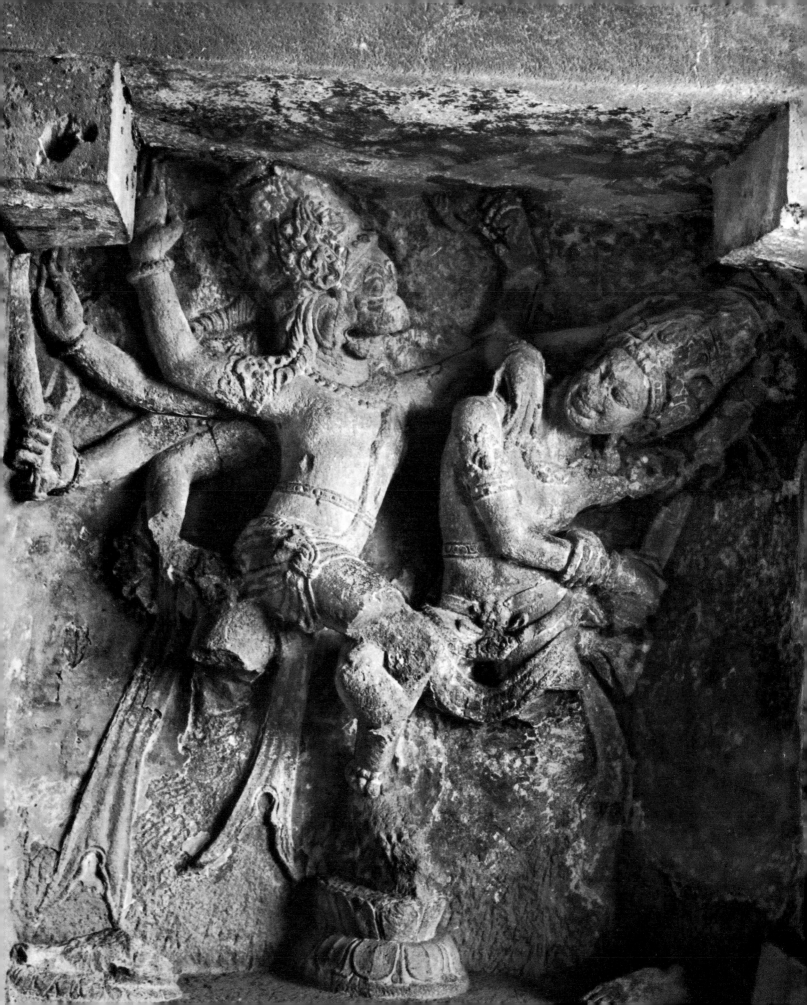

The Colour Library of Art

INDIAN ART

48 plates in full colour

Margaret-Marie Deneck

HAMLYN
London · New York · Sydney · Toronto

Acknowledgments

The objects and paintings in this volume are reproduced by kind permission of the following: Archaeological Survey of India, Calcutta (Figure 2); Bodleian Library, Oxford (Plate 30); British Museum, London (Plates 5, 14, 16, 20, 21, 24, 31, 32, 33, 34, Figure 5); Musée Guimet, Paris (Plates 1, 2, 3, 7, 8a, 8b, 10, 11, 12, 13, 15, 17, 22, 23, 36, Figures 4, 6, 7); Museo Nazionale di Capodimonte, Naples (Plates 6a, 6b); Museum van Aziatische Kunst, Amsterdam (Plate 26); Provost & Fellows, Eton College, Eton (Plate 27); Secretary of State for Commonwealth Relations, London (Figure 3); Victoria and Albert Museum, London (Plates 4, 9, 18, 35, 37, 38, 39, 40, 41, 42, 43, 44, 45, 46, 47, 48).

The photographs were supplied by the following: Louis Frederic – Rapho, Paris (Frontispiece); Michael Holford, London (Plates 1, 2, 3, 4, 5, 7, 8a, 8b, 9, 10, 11, 12, 13, 15, 16, 17, 18, 20, 21, 22, 23, 24, 27, 31, 32, 33, 34, 35, 36, 37, 38, 39, 40, 41, 42, 43, 44, 45, 46, 47, 48, Figures 4, 6, 7); Josephine Powell, Rome (Plate 19); Publications Filmées d'Art et d'Histoire, Paris (Plate 25); Madanjeet Singh, New Delhi (Plates 28, 29); University Press, Oxford (Plate 30).

Text translated by Alan Sheridan Smith

First published in 1967 by
The Hamlyn Publishing Group Limited
London · New York · Sydney · Toronto
Astronaut House, Feltham, Middlesex, England

ISBN 0 600 34703 6

Printed in Italy

Contents

Map Page 6
Introduction 7
Sculpture 13
Painting 20
Notes on the illustrations 26
Chronological Table 35

BLACK AND WHITE ILLUSTRATIONS

1 Narasimha. High relief.
2 Lion capital of Ashoka
3 Bas-relief from Bhārhut
4 Decorative ivory bands
5 Bas-relief from Amarāvatī
6 Statue of the god Vishnu
7 The god Vishnu. Carved stele

THE PLATES

1 Mother goddess statuette
2 Sculpture of a 'yaksha'
3 Gold necklace and ear-rings
4 Pillar from the Bodhgayā stūpa
5 Tree goddess from the Sāñchī stūpa
6 Ivory statuette
7 Ivory chair-back
8 Pillar from stūpa railings
9 Tree goddess from Mathurā
10 Sculpture of the serpent-king
11 The attack of Māra. Bas-relief
12 Bas-relief from Nāgārjunakonda stūpa
13 Bodhisattva from Shabaz-Garhi
14 The Bīmarān reliquary

15 Head of a monk
16 Gupta-style Buddha
17 Head of Avalokiteshvara
18 Torso of a Bodhisattva
19 'The Descent of the Ganges' (detail). Rock relief
20 Sculpted column base
21 The marriage of Shiva. Carved stele
22 Bodhisattva. Bronze
23 Mother and child. Temple relief
24 Shiva dancing. Temple relief
25 Divine couple. Temple relief
26 Shiva dancing. Bronze
27 Chandikeshvara. Bronze
28 Bodhisattva. Ajantā cave fresco
29 Ajantā cave fresco
30 Buddhist manuscript
31 The consecration of Mahāvira
32 The emperor Bābur inspecting a garden
33 Falcon
34 The three sons of Shāh Jahān
35 Ali Adil Shāh
36 Couple on a terrace
37 Krishna and Radhā
38 Kedara Rāginī
39 Todī Rāginī
40 The Rāja Ajit Singh
41 Queen and her buck
42 Muni Shri Sukdevji
43 Monk approaching Krishna
44 Nobles and dervishes
45 The holī festival
46 Durga slaying Mahishasura
47 Queen awaiting her lover
48 The swing

India

The principal sites
mentioned in the text

Begram
GANDHARA
JAMMŪ
Chamba
Basohli
Nurpur
Lahore
Kāngrā Kulu
PUNJAB
GHARWĀL
Harappā Sutlaj River
Jumna River
Ganges River
Indus River
Bīkāner
Delhi
NEPAL
Mohenjo Daro
RĀJPUTĀNA
Mathurā
Kanauj
Jodhpur
Agra
SIND
Kishangarh
Sārnāth
Patna Ganges River
MĀRWĀR
Bundi
Chambal River
Benares
Nālandā
Udaipur
Khajurāho
BIHĀR
Kotah
Bhārut
Bodhgayā
MEWĀR
MALVA
BENGAL
Sānchī
Calcutta
Bagh
GUJARĀT
Narbadā River
ORISSA
MAHĀRĀSHTRA
Dhauli
Konārak
Ajantā
Bhuvaneshvara
Ellorā
Godāvari River
Bombay
Elephanta
Ahmadnagar
DEKKAN
BAY OF BENGAL
Golconda
Bījāpur
Amarāvitī
Kistna River
Bādāmi
Vijayanagar
Lepakchi
MYSORE
Mamallapuram
Cauvery River
Tanjore
Sittanavasal
Madurā
CEYLON

AFGHANISTAN
TIBET
Indus River
ARABIAN SEA

0 100 200 300
Scale in miles

Introduction

The West knew of the existence of a civilisation in India as much as two hundred years before Alexander the Great, in the year 326 BC, brought his Greek army to the Indus valley as conquerors. This civilisation was mentioned and even described, though in a somewhat imaginative way, by Greek writers like Herodotus (*c.* 490 - *c.* 425 BC), called the 'father of history'. Their 'descriptions' were based on the accounts of such travellers as Skylax (an admiral of the fleet of Darius I) or Ktesias, both of whom were Greeks who had been in the service of the Persian kings, whose empire then included the Indus basin. About 517 BC, Skylax explored the course of the Indus on behalf of Darius. Ktesias, though he does not seem to have been to India himself, arrived at the court of the Persian king Artaxerxes I in 416 BC and spent seventeen years there, reporting what he had heard from travellers. It is obvious that their accounts were heightened by a considerable admixture of the marvellous. There were commercial relations between the two cultures and, in particular, Greece received cotton and spices from India.

Information about India was extended when the armies of Alexander the Great encountered the powerful kingdom of the Magadha (see page 10), and it was to this kingdom that Alexander's successors in Asia were forced to abandon the territories of the Indus which, since the time of Darius, had been satrapies or allies of the Persian Empire. A Greek from Asia Minor, Megasthenes, went to the court of the Maurya king Chandragupta (or Sandrakottos, as the Greeks called him) who had acceded in about 315 BC, as ambassador of Seleucus I, one of Alexander's Greek successor-kings in the Middle East. Megasthenes established direct contact with a purely Indian state, and it is to his book *Indica* that we owe the first detailed descriptions, not only of the geography, the flora and fauna of India, but also of its religion and of the division of society into rigid social classes or castes. The information provided by Megasthenes and by Nearchus who, on Alexander's orders, had descended the course of the Indus, was used by a number of later Greek and Latin authors, including Strabo (63 BC - AD 21) in his *Geography* (XV, 1), Pliny the Elder (1st century AD) in his *Natural History* (Book 6), Arrian (2nd century AD) in his *India* and Ptolemy (about AD 150) in his *Geography* (VII, 1-4). In his *Stromati*, Clement of Alexander (born AD 150) mentions the name of Buddha for the first time in European literature. With the increase in trade between the Graeco-Roman world, India and south-east Asia, at the end of the first century AD, a Greek merchant wrote a most valuable guide-book for travellers, the *Periplus (circumnavigation) of the Erythrean Sea*. (The term 'Erythrean Sea' included what are now known as the Red Sea, the Indian Ocean and the Persian Gulf.) This work describes the ports, gives information as to what goods may be bought and sold in them and indicates the conditions of navigation.

The rise of the Sassanian Persian Empire in the third century AD set up a barrier between the Graeco-Roman world and India and the knowledge of India by the West, whose main interest seems to have been commercial, declined. Later, with the birth and expansion of Islam, relations finally deteriorated between India and the West.

This situation was to last for centuries, interrupted only by the rare accounts of travellers who, from the thirteenth century onward, journeyed across Asia. But their accounts were as much legendary as well founded, as we can verify in the chapters on India in Marco Polo's memoirs. With the arrival of the Portuguese in India in 1498, documents concerning the country were collected and diffused by Portuguese historians. But it was not until the eighteenth century that European scholars undertook research on Indian civilisation, studied the *Vedas* (the Hindu scriptures) and founded, in 1784, the Asiatic Society of Bengal. A century later, in 1862, the Archaeological Survey of India was founded. It was from that date that Indian studies began to develop on a scientific, as opposed to a legendary basis.

The civilisation of India is one of the most important in the history of man. It probably developed between 1500 and 800 BC in the great northern plain, drained by the Indus and Ganges rivers where the Āryans, who were originally nomadic cattleherders, possibly from the southern steppes, had settled, invading India through the north-west passes and gradually extending their domination from the valley of the Indus to that of the Ganges. No evidence of its origins remains other than in the sacred texts, the *Vedas* (meaning 'divine knowledge'). For many centuries these texts were learned by rote and transmitted orally and only much later were they written down. In describing the victory of their

war god Indra over enemies in the fortified towns, the Āryans seem to be alluding to the conquest of the valley of the Indus. Excavations have revealed the existence in this valley of large cities (Harappā and Mohenjo-daro, the art of which is described on page 15), which provide evidence of a highly developed urban civilisation in contact with western Asia. These contacts have been confirmed, in particular, by the discovery in Mesopotamia of a number of seals, similar to those found in large numbers among the ruins of these cities and inscribed with the writing that still remains indecipherable. These seals have helped scholars to date the 'Indus' civilisation between 2500 and 1500 BC. It suddenly perished in a cataclysmic event which might have been either the Āryan invasion or catastrophic floods. Both hypotheses are tenable.

The Vedic literature includes many works which are fundamental to the development of Indian thought, an outline understanding of which is essential in appreciating all Indian art. The most ancient are the four holy books; the *Rig Veda* ('knowledge of verses'), the *Yajur Veda* ('knowledge in ritual forms'), the *Sama Veda* ('knowledge in sacred melodies'), to which were later added the *Atharva Veda* ('knowledge of the Atharvans, from the name of a family of priests who possessed particularly magical powers). They are written in Sanskrit, an Indo-European language distantly related to Greek and Latin. The *Rig Veda*, the oldest of the scriptures, consists of a thousand hymns in honour of divinities which are generally personifications of natural forces: Agni — (the god of fire in all its forms, from the fire of the heavens to domestic fire; compare the Latin *ignis*), Sūrya and Vishnu (the sun), Ushas (the dawn), Varuna (the ocean), Indra (the god of war and dispenser of thunderbolts, rain and lightning), and Rudra (god of the forests).

Commentaries were attached to these texts: the *Brāhmanas* (the 'interpretation of the Brahmins'), in which the ritual acts of sacrifice (which was central to the Āryan cult), are given far greater emphasis than the gods themselves; the *Āranyaka* ('texts of the forest') and the *Upanishads* ('esoteric doctrines'), in which appear the concepts of *brahmā*, the sacred energy which is released through word and sacrifice, and of *ātman*, the immutable essence of being and of the individual soul. Although the Vedic gods are still named, brahmā is regarded more and more as the essence of being that pervades the universe, as the universal soul with which the soul of the individual was to become equated in Hindu thought. There also appear the *Dharma*, the concept of divine order, to which is related the division of society into castes, and the doctrine of *samsāra*, or transmigration of souls. Until it is absorbed in the *brahmā*, which alone can bring it deliverance (*moksha*), the soul passes from one existence to another, enduring the consequences of its actions (*karma*). (In ancient Vedic times, *karma* was simply ritual acts, but it subsequently came to mean any conscious action involving responsibility and the result of actions in one life affecting the next.) *Karma* justifies the inequality of the caste system, birth into one or another caste being not an arbitrary event, but the result of previous actions. The castes are four in number: the brahmins (priests), the kshatriyas (warriors), the vaishya (freemen) and the shudra (slaves and artisans). The first two were ruling classes, concerned with the continuance of the cult and with the defence of society respectively.

It is difficult to know anything about Indian history, particularly early history. It is often considered that the Indian mind does not possess an historical sense because it is unused to thinking of the past in terms of sequence, and so was slow to record chronological history. External events alone allowed scholars to date certain facts with accuracy. The sixth century BC seems to have been an important period in Indian thought, being the time when Vedism evolved toward Brahmanism, and it saw the founding of two great new religions, Jainism and Buddhism. Their founders, Mahāvira, 'the Great Hero' and Buddha, 'the Enlightened One', were historical characters whose lives were subsequently embellished with legend. Both belonged to the warrior-class, accepted the doctrines of transmigration and the possibility of deliverance, but were less concerned than the traditional priesthood with theoretical speculations about the nature of being. They sought, the Buddha especially, a remedy for human suffering. Jainism is based on a pantheism embracing the whole of nature and its principal doctrine is non-violence, *ahimsa*, by which it is forbidden to harm any form of life. Buddhism, which is closer to the aspirations of ordinary people, bases its teaching on love of one's neighbour and compassion for all beings. It denounces the caste system, rejects the power of the brahmins and exercises an ethical

influence on behaviour, since deliverance is obtained not by ritual acts (such as sacrifices and gifts to the brahmins) but by the practice of virtue.

The Buddha was born Prince Siddhārtha at Kapilavastu, at the foot of the Himalaya mountains, in the royal family of Shākya, to which he owed his title, Shākyamuni, 'the Sage of the Shākyas'. There are many legends surrounding his life and a knowledge of these is needed for an understanding of Indian sculpture and painting for each stage of the Buddha's many existences plays a part in the art of India. According to legend, his birth was accompanied by extraordinary events: he emerged from the right side of his mother's breast, was received by the gods Indra and Brahmā (the 'creator of the world') and immediately took seven steps in each of the four directions, thus assuming possession of the world. During his childhood and youth, he excelled in every exercise, intellectual and physical, and he was compelled to emerge victorious from various trials before marrying Yashodharā. He thus led a life that was sheltered from all suffering, until one day, by chance, he encountered, in turn, an old man, a sick man and a dead man. Meeting human suffering for the first time, he meditated upon mortality and the vanity of pleasure. A fourth meeting, this time with a monk, showed him the only remedy for this suffering. Shākyamuni left his palace in the middle of the night, accompanied only by his faithful squire, and the gods held the hooves of his horse from the ground, so as not to make any noise. At the edge of the forest, he changed from his princely clothes into those of a hunter, dismissed his squire and horse cut off his hair, which was taken away by the gods, and began to lead the life of a wandering ascetic. For six years, surrounded by five disciples, he subjected himself to terrible austeritici. Recognising that this was not the way to salvation, he accepted, in front of his scandalised disciples, who then left him, the food that had been prepared for him by a young woman called Sujātā and then bathed in the river Nairañjanā. Seated on a tuft of grass, he abandoned himself to meditation at the foot of a fig-tree. This was the moment chosen by the demon Māra 'he who makes [creatures] die', the Buddhist devil, to try to prevent him from attaining spiritual enlightenment or *bodhi*. Māra sent his army of monsters; their attacks, however, were easily repulsed by Shākyamuni,

who changed into flowers these and the many various missiles that were thrown at him. Māra then ordered his three beautiful daughters to try every means of seduction, but, though they displayed all their charms, Shākyamuni did not at first notice them and remaining impervious, finally changed them into three old women. Eventually he emerged from meditation. He now understood the causes of universal suffering and its only remedy, the annihilation of desire. Thus attaining the state of enlightenment (*bodhi*), Shākyamuni became a Buddha. For a long time he remained in meditation at the foot of the Tree of Wisdom, the sacred Bo tree, and to protect him from the storm that had broken out without his even noticing it, the serpent (*nāga*) Muchilinda made him a seat out of the coils of his body and sheltered him by spreading his seven-headed hood over him. Finding his five former disciples in the Deer Park at Benares the newly enlightened Buddha preached to them in these terms:

There are two extremes, O monks, that must be avoided: a life of pleasure, which is base, ignoble, unworthy, vain and contrary to the spirit, and a life of mortification, which is sad, unworthy and vain. The Perfect One, O monks, has avoided both these extremes, and he has found the way that leads between them, which leads to rest, to knowledge, to enlightenment, to *nirvāna*.. This, O monks, is the holy truth concerning suffering: birth, old age, sickness, death, separation from what we love are suffering. This is the origin of suffering: the craving [*tantra*] for pleasure, the craving for existence, the craving for non-existence: And this is the truth concerning the suppression of suffering: the extinction of this thirst through the annihilation of desire.

He was soon followed by a great many disciples and the community of Buddhist monks was founded. They lived in monasteries and begged for their food. The Buddha then returned to Kapilavastu, his native town, and converted his family. He continued to lead the life of a wandering monk until his death at the age of eighty, thus attaining to *nirvāna*, 'blowing out' or transcendent repose in final extinction which freed him from the cycle of existences.

The Buddhist texts relate not only the last earthly life of the Buddha, but also his many previous existences in the early Buddhist legends of the *jātakas*, in which he appears sometimes in animal, sometimes in human form, but always

as an essentially charitable creature. There are, among others, the elephant with six tusks, who, pierced by a poisoned arrow from a hunter's bow, prevents his herd from trampling the hunter to death; the hare who offers himself as food to a Brahmin; the king of the stags who takes the place of a pregnant doe about to be delivered as tribute to the king of Benares; the monkey who used his own body as a bridge to allow his fellows to escape from a trap that had been set for them; the king Sibi who gave his own flesh as food to ransom a pigeon from a famished falcon; the king Vessantara who gave away all his possessions and even his children to beg for Brahmins and then gave them his wife as the ultimate renunciation in his career of *dāna-paramitā* 'the perfection of giving'.

At the end of the sixth century BC, the Indus valley (Punjab and Sind) was conquered by Darius I and passed under the domination of the Persian Empire. It remained in the possession of the Achaemenid dynasty of Persian Kings until its brief occupation in 326–5 BC by Alexander the Great of Macedon who had defeated Darius III, the last of the Achaemenid Great Kings. The rest of India seems to have been divided at this time into a number of states, which did not, however, prevent the spread of the new religions and the rise of the level of culture generally. At the end of the fourth century BC the kingdom of Magadha (in the eastern valley of the Ganges, now Bihār), under the Maurya dynasty, became the most important of these states. The founder of the Maurya empire, Chandragupta, reconquered the valley of the Indus from the Greeks (see page 7). His grandson, Ashoka (about 264–227 BC), brought this empire to the height of its power and achieved the first unification of India. Except for the extreme south it came entirely under his domination. Through the embassies which he sent to a great many countries, and by means of the missions of Buddhist monks, Ashoka spread Indian culture outside the subcontinent. Ashoka was a devout Buddhist and throughout his empire he had moral edicts, which were inspired by the Buddhist teaching on charity, inscribed on rock or on pillars. These familiar pillars with their lion capitals (the emblem of independent India) and the ruins of Ashoka's palace at his capital Pātaliputra (now Patnā), are the oldest known examples of Indian art apart from those of the Indus civilisa-

tion. The style of Ashoka's pillars shows the influence of Persian art in its Hellenised phase after the conquests of Alexander.

The political unity of India did not survive long after Ashoka's death. His empire gradually split up, but the Shunga dynasty (about 176–64 BC), which succeeded the Maurya in Magadha, maintained a high artistic and cultural tradition. The earliest specifically Buddhist monuments are stone-built stūpas which are used either as reliquaries or as commemorative monuments. They reveal a fully fledged art and lead one to suppose that there must have been earlier buildings made of more perishable materials. Stūpas are a development of the tumuli, or sepulchral mounds, of the Vedic period (see page 8). They are hemispherical in shape and are placed on a base that is generally square, and are topped by a small square railing, supporting the mast of the halo-like shielding umbrellas above. Carved stone railings run round the bottom, with one or four carved gates and sometimes a high porch in front of them. The best preserved and also the best known is Stūpa 1 of Sāñchī at Bhopal. Other forms of architecture which also date from this period are sanctuaries with apsidal ground-plans and monasteries with square ground-plans, cut out of the rocky surface of cliffs, mainly in Mahārāshtra, in the Bombay region. Both the free-standing and the rock-hewn buildings are peculiar in that they faithfully copy wooden constructions: the sections of the balustrades round the stūpas are fitted by tenon and mortise, while the surface details of carpentry are reproduced on the vaults of the rock-cut sanctuaries.

In the north-west of India, the Greeks had founded dynasties which were still flourishing during the second and even the first century BC. But at the end of the second century BC, the migrations of the peoples of Mongolia and Central Asia drove Iranian groups, such as The Sakas (Latin, *sacae*) and the Parthians over the mountain passes towards the Indus valley and Indo-Parthian kingdoms came into being beside the Indo-Greek kingdoms, in northern India. Then, at the beginning of the Christian era, the Indo-Scythian peoples (possibly from the steppes, north of the Black Sea) founded a great new empire that stretched from Central Asia to the valley of the Ganges and from the Oxus to the Punjab. This was the empire of the Kushāns, made famous by the reign

of its ruler Kanishka and his conversion to Buddhism. The dynasty of the Āndhras was reigning in the Dekkan, sheltered from foreign invasion but in touch with the Indo-Parthian and Indo-Scythian kingdoms.

This whole period from the beginning of the Christian era to about the fourth century AD was one of transition that culminated in a fully developed power of expression in art. It was notable for three different but roughly contemporary schools. In the north-west, mainly in the provinces of Gandhāra and Kāpisha where the Indo-Greek satraps had reigned, was the so-called Graeco-Buddhist school, characterised by the use of Hellenistic elements superimposed on Indian themes. In the north was the school of Mathurā, which had been an important centre under the Kushān dynasty, and, in the south-east was the school of Amarāvatī showing traces of Roman influence due to the existence of commercial centres on the south-eastern coast and which constituted the art of the Āndhra dynasty. All three of these schools continued the earlier tradition of the Shunga period, though perfectly assimilated external influences are also apparent, particularly at Mathurā. This seems to have been the period of a general spread in the use of the Sanskrit language, which was now used for profane as well as for sacred purposes, and to have seen the completion of the two great poetic epics, the *Mahābhārata* and the *Rāmāyana*.

The two major religions, Brahmanism and Buddhism, continued to develop. They absorbed popular cults, borrowed from each other and both tended towards universalism. Two tendencies developed within Buddhism. While the original doctrine continued to be taught in the Hīnayāna, or 'Small Vehicle', which sought above all personal salvation, *nirvāna*, and whose ideal was the monastic life, the Mahāyāna, or 'Great Vehicle', was more complex. A whole philosophy developed and very soon the Buddha was accompanied by an entire pantheon. These consisted, in particular, of abstract Buddhas: Amitāyus ('Infinite Duration') Amitābha ('Infinite Light') and, above all, the Bodhisattvas, eminently charitable beings who, although about to enter the state of Buddha-hood, postpone this supreme moment indefinitely in order to devote themselves to the salvation of men. The principal Bodhisattvas are Maitreya, the next Buddha to appear on earth, who can be recognised by his waterpot, the emblem of the Brahmin caste in which he will be reincarnated; Mañjushrī, the lord of transcendent wisdom, whose attributes are a book, a sword and a blue lotus; Avalokiteshvara, the merciful, a spiritual emanation of Amitābha, whose image he wears in his hair and whose attributes are the lotus blossom and the rosary.

The gods of the Brahmanic pantheon became personalised and soon two of them, Shiva (a development of the Vedic Rudra), and Vishnu were given pre-eminence and became, for their devotees, the supreme divinity towards whom everyone may strive in different ways: knowledge (*jñāna*), ascesis (*yoga*) and mystical love (*bhakti*). This last way has been magnificently celebrated in a poem, the *Bhagavadgītā*, the 'Song of the Blessed', which forms part of the epic of the *Mahābhārata* and depicts Vishnu himself in one of his incarnations, Krishna. For the ·god is both one and multiple and he performs numerous earthly descents (*avatāra*) in order to save the world whenever it is in danger:

> Though I be spirit, without beginning and
> without end, though I be the Lord of all
> creatures, I am born out of my own power
> and out of my own nature.
> Whenever order is disturbed, whenever
> disorder rises, I create myself anew.
> From age to age, I am reborn to
> protect the good, to confound the wicked
> and to re-establish the reign of order. *Bhagavadgītā* VI. 6-8

There are ten principal incarnations of Vishnu, in either animal or human form: the fish (Matsya), the tortoise (Kurmā), the wild-boar (Varāha), the man-lion (Narasimha), the dwarf (Vāmana), the ascetic (Parashurama), Rāma (the hero of the epic of *Rāmāyana*), Balarāma (the brother of Krishna), Krishna (the god-shepherd), and Kalkin (the man with a horse's head), who will become incarnate at the end of the present age.

Shiva has no incarnations, but he has many different aspects nonetheless. Among these are Natarāja (Lord of the cosmic dance), Bhairava ('the terrifying one'), Vinādhara (master of the arts and sciences) and even the *lingam*, the phallic symbol that represents him and denotes his male creative energy. He is the pantheistic god *par excellence* and it is as such that he is invoked in the Harivamsha:

I adore thee, father of this universe, which you traverse by invisible ways, great mystic tree with shining branches, terrible deity of a myriad eyes and a hundred suits of armour. I implore thee, being of divers aspects, sometimes perfect and just, sometimes false and unjust.

The beginning of the fourth century brought a new period of unity to India. It was once again a prince of the Magadha, called, like the founder of the Maurya empire, Chandragupta, who initiated it and founded the Gupta dynasty which reigned over India for almost two centuries. Gupta domination was marked by a highly developed intellectual culture which survived its eventual fall and which has made this period the high point of Indian civilisation. Remarkable works were produced in every domain: treaties of Mahāyanist philosophy, which were to form the basis of the development of Buddhism throughout Asia; the development of an enhanced version of Vedic scriptures known as the *Vedānta*, one of the most famous Hindu systems; poetry, music, drama, the last of which was dominated by the personality of Kālidasa (the author of, among other works, the famous play *The Recognition of Shakuntalā*), a writer who had a perfect mastery of the art of suggesting without stating, which was the ideal of this period; and sculpture, frescos and architecture that attained a great purity of form. Brahman temples, built of durable materials and generally small in size, appeared beside the Buddhist stūpas, while rock-cut architecture, which remained in fashion for a few more centuries, revived earlier forms, but with a profusion of sculpted or painted decoration (Ajantā, Bādāmi, Ellorā).

The invasion of the Ephthalite or 'White Huns' from Central Asia in the second half of the fifth century brought about the collapse of the Gupta empire, already undermined by the growing power of the vassal kingdoms which now regained their independence. One of these kingdoms, that of Kanauj, under the reign of Harsha (606–647), re-established for a short time, the political unity of India.

During the whole of this period, Indian influence spread across Asia, in essentially peaceful ways, both by Buddhist missionary propaganda and by the extensive trade carried on along the Silk Road and the caravan routes of Central Asia or along the maritime route opened up by Roman traders through the Indonesian islands to China. It was this two way traffic that enabled India to influence the Asian countries to such a large extent. For example, Indian and Chinese influence coincided in Tibet in the seventh century when the country was converted to Buddhism. Culture remained at a high level in the western Dekkan under the dynasty of the Chālukya (about 550–757), then under the Rāshtrakūta (757–973) and in the eastern Dekkan under the Pallava, who built a remarkable group of buildings at Māmallapuram. In Bengal, under the Pāla dynasty (eighth to twelfth century), Buddhism enjoyed a final expansion, due in particular to the influence of the university of Nālandā, a medieval centre of Buddhist learning in North-eastern India, which attracted large numbers of pilgrims.

During the eighth century, however, the Arabs had arrived by the sea trading route and had begun to invade Sind (the lower valley of the Indus) and Arab art of the Abbaside caliphate maintained a stronghold from the eighth century. At first, the Moslem invasions presented no great danger, but the situation became catastrophic about the year 1000 with the arrival of the Moslem afghans under Mahmūd of Ghazni, who waged a holy war against the Hindus, seized the Punjab and reached the valley of the Ganges, sacking, in particular, the region of Mathurā and Kanauj. In the twelfth century, Mohammed of Ghor founded the Sultanate of Delhi and advanced as far as Bihār and Bengal, where he destroyed the many Buddhist monasteries that flourished there. Buddhism, which is essentially a monastic religion, was never to recover from this terrible blow and it soon disappeared from India itself. However, those monks who had escaped the massacre took refuge in Tibet or in South-East Asia. Brahmanism, which was intimately linked to social organisation, resisted more strongly, but its development was arrested, it turned inwards upon itself and became stricter and more rigid.

Hindu temple architecture had developed quite considerably since the Gupta period. The sanctuary had been transformed into a veritable sanctuary-tower, with a curvilinear roof. This first type was characteristic of the architecture of the North (Bhuvaneshvara, Khajurāho) while a pyramidal roof was typical in the South (Tanjore). The sanctuary no longer stood alone, but formed part of an ever-larger complex of buildings within an outer wall.

In the Dekkan, the Moslem advance was less rapid. After the Chola dynasty (about 850–1267), which built very fine temples, Hindu culture was defended against Islam by the Hoyshala (about 1110–1327), the Pāndya (about 1212–1327) and then by the kingdom of Vijayanagar, which was founded in 1336. This kingdom resisted until 1565, when it was at last conquered by the Mughals. The Mughals, who were also Moslems, were newcomers to India. The first two Mughal emperors, Babur (1494–1530), a descendant of the Mongol Tamurlane and Humāyūn (1530–40), were military adventurers expelled from Turkestan by the Uzbeks. Their cultural background was Turkish. After invading the Ganges valley, they built up a powerful empire which, for the third time in history, revived the political unity of India. The Mughal dynasty was dominated by the Emperor Akbar (1556–1605), a tolerant man who appreciated Hindu culture and whose reign, like those of his successors, Jahāngir (1605–1627) and his son, Shāh Jahān (1627–1658), saw the development of a very refined Indo-Islamic, or Mughal art. Its decline was brought about by the intolerance of Aurangzeb (1659–1707). A fanatical Moslem, he destroyed the equilibrium of his empire by persecuting the Hindus and his reign ended in near-anarchy. Aurangzeb dealt a terrible blow to Mughal art by persecuting artists and proscribing the representation of the human figure. Hindu art also declined and having lost its original creative impulse, it survived only in a markedly artificial and over-elaborated form; a tendency which increased right up to modern times and the bastardisation of form and decoration is apparent in those temples built since the eighteenth century.

SCULPTURE

The art of India can only be understood in relation to the essential characteristics of the country that produced it. Thus its slow development is due to a respect for tradition. Forms do not suddenly change, but alter gradually. Indians have a taste for codifying rules and regulations, a characteristic to be found in the caste-system and permeating every sphere of activity. The artist, in particular, must conform to a fairly strict system of aesthetic principles; his aim is to create not a work of art as such, but a religious work which, if it is to have value, must scrupulously respect the established rules.

To the Indian sculptor the purpose of a statue is to serve as an aid to meditation and its position, its expression, its gestures and even its costume have a very precise meaning. The principal gestures, which are also those of dancers and actors, are known as *mudrā* in Buddhist and as *hasta* in Brahmanic works. They include the gesture of meditation (*dhyanamudrā*), in which the hands are placed flat on top of each other and which is associated with the eastern position of sitting cross-legged; the gesture of charity (*varamudrā*), in which the hand is lowered, with the palm turned outwards; the gesture of absence of fear (*abhayamudrā*), in which the hand is raised to the height of the shoulders, with, again, the palm turned outwards: the gesture of preaching (*dharmachakramudrā*), in which the hands are placed at chest height in the position for turning a wheel—for the preaching of the Buddha set the wheel of the Law in motion; the gesture of argument (*vitarkamudrā*), in which the hand is raised, with the thumbs and index-finger touching; and the gesture of adoration or salvation (*anjalimudrā*), in which the hands are joined together and raised.

Artists were regarded as practitioners of a particular craft and were probably divided into craftsmen's guilds. The texts and inscriptions make particular reference to those of the architects, the sculptors and the ivory-workers. This last guild seems to have been particularly flourishing at about the beginning of the Christian era. An inscription on the south gateway of Stūpa 1 of Sānchī states that it is a gift from the ivory-workers of the neighbouring town of Vidisha. Their clientèle extended far beyond their own regions, as is shown by the numerous plaques in worked ivory that were found in the excavations at Begrām of Kāpishi (figure 3 and plate 7). The export of their works seems to have reached even as far as the Roman empire, since an ivory figurine of Indian origin was found in the ruins of the Italian sea-side town of Pompeii, buried by the eruption of Vesuvius in AD 79 (plate 6).

Most Indian works of art are associated with a particular religion: Buddhist, Brahmanic or Jain. Secular art certainly did exist, as the ivories of Begrām show—these were, in fact plaques used to decorate seats intended for women's quarters (plate 7)—but in India it is difficult to distinguish between religious and secular art. There is an interpenetration of the human and the sacred and many works, which to our western

eyes look secular, are in fact religious. A Buddhist pilgrim piously performing the ritual circumambulation (*pradak-shinā*) around the stūpa, learns to recognise not only the last life of the Buddha or his previous lives, but also scenes of daily life as the artist knew them.

From ancient times sculpture has formed an integral and very important part of Indian architecture. Certain works of architecture, such as the monolithic temples of Māmalla-puram or the Kailāsa of Ellorā, which stands in the middle of an open-air arena, are simply gigantic works of sculpture in the round.

The earliest known works of Indian art are those which were found on sites in the Indus valley and date from between 2500 and 1500 BC. Apart from a few small stone sculptures (busts from Harappā, the bust of a priestlike figure from Mohenjo-daro) and a bronze statuette of a dancing-girl, they are usually rather crudely cast terra-cotta figurines of women, with applied ornamentation, or figurines of animals which already reveal the Indian artist's powers of observation—a talent which is also to be found in the numerous seals which very often depict an animal in profile. It is possible that the production of terra-cotta statuettes, which were objects of popular religious devotion and usually depicted the prehistoric cult of the Mother Goddess, continued unbroken from age to age. In any case, they still existed in the Maurya period (plate 1), when historical Indian art appears with the columns of Ashoka. These reveal an imperial art that has borrowed a great deal from Hellenised Iran (figure 2), an influence that is particularly apparent in the polished surface of the stone and in the bell-shaped capitals surmounted by stylised lions carved in the round (such as with the columns of Sārnāth and of Lauriyā-Nandangarh). A more naturalistic style of treating animal figures is seen in the bull surmounting the column of Rām-purvā and in the animals (the bull, the elephant and the horse) in the bas-relief which alternates with the Buddhist symbol of the Wheel of the Law round the abacus of the lion-capital of Ashoka's pillar at Sārnāth, as well as in the elephant at Dhauli (Orissa), which is carved in a rock bearing an inscription by Ashoka.

Sculpture in stone appeared in the Maurya period, and made its greatest advances during the Shunga period. Sculpture

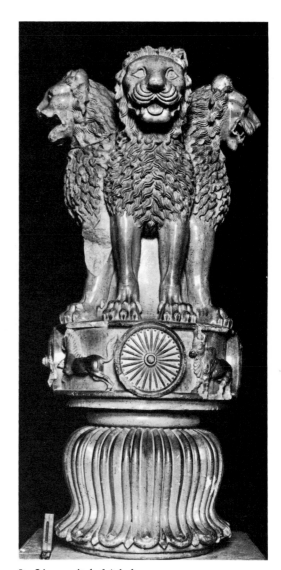

2 Lion capital of Ashoka

in the round has a heavy, solid, rather rough appearance, but already reveals the Indian taste for precision and finished detail in the clothes and ornamentation. The few specimens that have survived represent Yaksha (local divinities—plate 2). But it is in the bas-reliefs that the artists reveal all their skill.

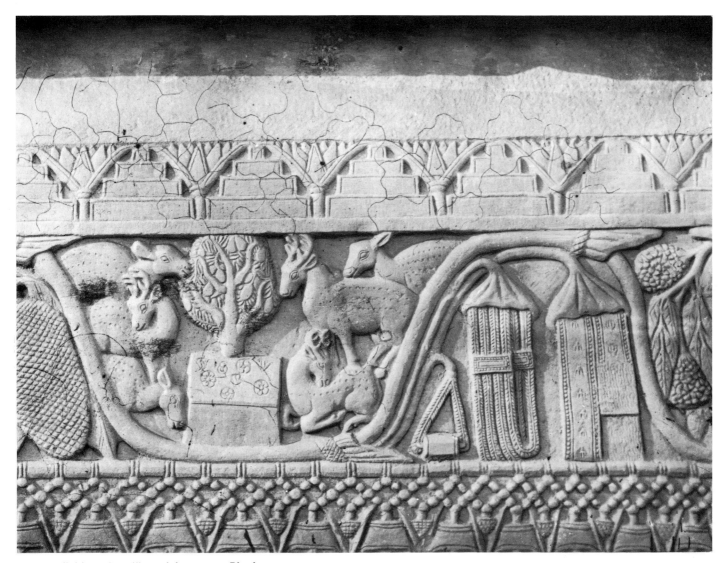

3 Bas-relief from the railings of the stūpa at Bhārhut

They were intended both for the edification of pilgrims and as decoration for the railings of the stūpa. The quality of the bas-reliefs varies from site to site, being still rather flat and clumsy at Jaggayapeta in south-east India, while on stūpa 11 of Sānchī they are essentially decorative and symbolic (lotus, garlands of flowers, numerous, sometimes rather fantastic animals carved in the medallions or semi-medallions on the pillars). At Bhārhut and Bodh-Gayā (plate 4), they are narrative, telling the stories of the Buddha's previous lives (*jātaka*) with a few scenes from his last life. These

charming, sometimes naive but always well-observed works reveal a very confident feeling for composition and a quite definite decorative sense. The many scenes depicting animals give the artists an opportunity to indulge their taste for the picturesque. At Bhārhut, where the name of each *jātaka* is inscribed above the scene depicting it, each representation has its place in a decorative whole, ornamenting either the handrail (figure 3), where they alternate with floral motifs in the foliage of a lotus garland, or the medallions on the pillars, which are also decorated with stylised lotus flowers. The medallions on the pillars are replaced at intervals by the tall, priest-like figures of Yaksha or Yakshī, which already show the tilted hip position characteristic of Indian female figures in sculpture.

The railings of the Stūpa 1 or 'Great Stūpa' of Sānchī is undecorated, but the pillars and lintels of the gate-ways are decorated with bas-reliefs representing the same scenes as those at Bhārhut, but in more elaborate compositions involving a greater number of characters, with a more accentuated relief and an effect of perspective achieved by the use of different planes. Tall figures of Yakshī in the round, with accentuated hips, decorate the east and north *toranas* (monumental gateways). They stand on the carved branch of a tree and seem to support the ends of the lower lintel. The façades of the many rock-cut sanctuaries are also sculpted with bas-reliefs. Towards the end of this style, erotic human couples (*maithuna*) appear, a subject which was to continue into the medieval period.

In none of the art of this period is the Buddha himself represented in the scenes of his last life: his invisible presence is simply suggested by means of symbols. Thus an umbrella surmounting a riderless horse represents the Great Departure of the Buddha from his palace; an empty throne at the foot of a tree suggests the moment when he at last attained Spiritual Enlightenment (plate 11); even a foot-print is enough to indicate his presence, while the Wheel (symbol of the Law) represents him preaching and, if flanked by deer, his first sermon in the Deer Park at Benares.

The image of the Buddha makes its appearance in the transitional period (see page 71), shortly after the beginning of the Christian era. This was long believed to be due to the influence of the Hellenistic art which the Greek dynasties had planted in north-west India. The connection was suggested by the 'Apollonian' type of Buddha created by the Graeco-Buddhist school of sculpture which now flourished in this region, after the close of the Hellenistic phase, but it seems that, simultaneously, a distinctively Indian type had appeared at Mathurā, deriving from the Yaksha of the previous period. Whatever its origin may be, the use of the Buddha figure strongly affected the three artistic schools of this period, although the ancient symbols continued to be used parallel to it at Mathurā and Amarāvatī.

Graeco-Buddhist art is known to us by a large number of statues and bas-reliefs from the ruins of stūpas in the north-west of India. It stands somewhat apart from strictly Indian art, for though its themes may be Buddhist, its style is Hellenistic. Moreover, in the decoration itself, there are to be found, beside some purely Indian themes, such as railings, other motifs that are entirely Greek: palmettes, vineleaves, garlanded Cupids, winged atlantean figures and Corinthian capitals (often Indianised, however, by the presence of a small Buddha among the foliage). Its appearance is fairly conventional, whether it is a piece of sculpture in the round or a bas-relief executed in bluish or greenish shale. The figured scenes display a tendency to symmetry in composition. The 'Apollonian' Buddha can be recognised by his distinctive signs: the *ūrnā*, or the whorl of hair between the eyes; the Wheel (*chakra*), symbolising the Buddhist Law, cut into the palms of the hands; the hair tied at the back by a small cord — the deformation of which will later produce the cranial protuberance (*ushnīsha*). The hair, which is at first depicted in even waves, is later made curly. The facial features are regular, a Greek nose continuing the line of the forehead, arched eyebrows in relief, half-closed eyes and distended ear-lobes, which recall the Buddha's life as a prince, when he wore heavy jewels in his ears. He is dressed in the linen robe of a monk, the folds of which are in relief. The bare-chested Bodhisattvas who also wear linen robes that are draped over the left shoulder, can be recognised by their jewels and the more elaborate style of their hair (plate 13).

But side by side with these somewhat academic works in shale, the Graeco-Buddhist sculptors made a great many works in stucco; these also decorated the stūpas, but are

much more vital (plate 15). The faces in these works are very well observed and are interesting in that they faithfully portray a variety of ethnic types.

The Mathurā school of sculpture (first to the third centuries), on the other hand, continued the artistic tradition of the previous period. Foreign influences can be detected, however, particularly from Parthian Iran, which is understandable, as this region was then under the domination of the Kushāna dynasty and Mathurā in the north was their winter residence. Since the surrounding quarries produced pink sandstone, this material was used by the artists. Most of the works are Buddhist, but there is also Jain and Brahmanic sculpture, as well as secular work. The statues of emperors or great dignitaries can be recognised by the costumes, which are those of the nomad peoples of the steppes; long tunics that flare out at the bottom, tied by decorated belts, Scythian caps, boots. The Buddhas of this school have round faces, shaven heads and skull-caps. Their monastic robes leave the right shoulder bare, are close-fitting and fall in concentric folds in shallow relief (plate 8). The female figures that decorate the pillars of the stūpa are less rigid than in the previous period: despite their opulent forms, they gracefully depict the triple flexion or *tribangha* peculiar to Indian art, with its remarkable feeling for the beauty of the body (plate 9). The execution of all these sculptures is characterised by a clear line and a simple relief.

The carved or engraved ivory plaques from Begram (Afghanistan), the summer capital of the Kushāna empire, belong to the Mathurā aesthetic with its unmistakable traces of Iranian influence. They provide overwhelming evidence of the confident mastery and technical diversity of the ivory-workers of this period. Some of the plaques are simple line engravings, while others give an impression of relief, with the undecorated part cut away. Others are treated in high relief, sometimes being carved on both sides. Their ornamentation is also very varied. In addition to scenes from the women's life of the period, there are also decorative motifs that reveal a great richness of composition (figure 4).

The Amarāvatī school (second to the fourth centuries) also continues the tradition developed by the artists of Bhārhut and Sāñchī. But these sculptors were also innovators. No longer content with decorating railings and gate-ways,

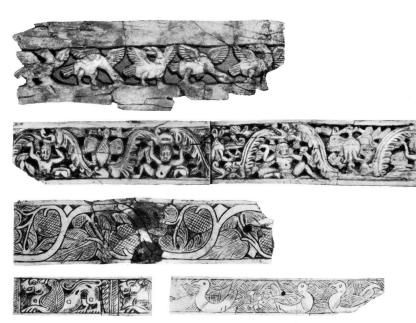

4 Decorative ivory bands

their sculpture was extended to the main body of the stūpa, of which there were a great many under the reign of the Āndhra in the region between the rivers Krishnā and Godavarī. This work shows a great improvement in the use of perspective and a remarkable sense of movement and composition. The circular form of the medallions in which the supple, graceful and slender figures are enclosed is brilliantly developed. The refined art of these sculptors harmonises particularly well with the materials in which they work — either marble or white limestone. The decorative motifs — lotus, garlands, animal friezes — are to be found on the outside of the stūpa railings, whereas the insides, as in the previous period, are covered with narrative bas-reliefs. These use either the new iconography (which does not hesitate to represent the Buddha himself) or the ancient inconography in which his presence is merely suggested by symbols (plate 11). Is is not uncommon for both iconographies to be used in two different scenes on the same pillar. When the Buddha is represented, he is shown wearing the monastic robe, which falls in regular folds and is draped over the left arm, leaving

the right shoulder uncovered, with his right hand making the gesture of absence of fear. His head and cranial protuberance are covered with flat hair that is ritually curled clockwise.

With the Gupta period (fourth to the fifth centuries) the truly classic period of Indian art, sculpture reaches its highest development. Despite its attachment to earlier styles, it now reveals quite different preoccupations. Brahmanic sculpture, which had already appeared in the Mathurā school, now develops to a point at which it begins to rival Buddhist sculpture. Both are remarkable for their purity of form, for the balance and harmony of their proportions, yet each is expressive of its own particular spirituality. The rock-cut sanctuaries of both religions reveal a decided tendency to ornamentation, not only on the walls, but also on the pillars as far as the entablature supports and high friezes. The Buddhist works are dominated by a feeling of detachment, peace and serenity. The statues, which are generally very high, are no longer really in the round, but are backed by a stele. The Buddhas conform to canonical regulations and continue earlier tradition (plate 16). There are the same distinctive features, but the expression of the face is one of inner concentration. The cloak, which at first was draped in very fine folds, is made transparent to reveal the shape of the body; then, very rapidly, it loses any trace of folds altogether, sticks closely to the body and is visible only by slight indications at the neck, the wrists and the ankles. Often the face stands out from a wide circular nimbus decorated with lotus petals and foliage. The Bodhisattvas, whose bodies describe the canonical triple torsion, possess the same plastic qualities (plate 18). They are dressed as princely characters and wear a simple draped loin cloth or *dhoti*, tied with a belt, which leaves the chest bare, and a number of jewels that are treated in great detail. The Buddhist bas-relief, on the other hand, loses its former qualities. The narrative scenes of earlier periods are replaced by compositions of a more monotonously monumental and architectural character.

The Brahmanic divinities are treated as princely characters and are very similar to the Bodhisattvas. The Brahmanic reliefs show, according to the site, the same qualities of elegance and restraint as Buddhist sculpture (the bas-reliefs illustrating the legend of Rāma at Deogarh, for example) or a feeling for the monumental and for composition (as in the

Varāha of Udayagiri in the state of Bhopāl).

The Jains make use of the Buddha-type figure for their own sacred characters (the so-called 'Victors' or *jinas*), who are distinguishable from the Buddhas only by their nudity and the absence of distinctive emblems (*ūrnā*, *usnīsha*), which are replaced by their own symbol, the *srivatsa* (an auspicious symbol) engraved on the chest.

With the post-Gupta style, from the sixth century, the images retain the same characteristics, but they follow increasingly strict canonical rules and become more impersonal. The Buddhas become fleshier and although the princely characters (Bodhisattvas and Brahmanic divinities) retained their slender figures, they wore more and heavier jewellery.

The Buddhist bas-reliefs gradually become stereotyped: the façades of the Buddhist rock-cut sanctuaries are covered with series of Buddhas, standing or sitting, surrounded by assistants of smaller stature. There are but a few monumental compositions such as the Parinirvāna (death of the Buddha) in caves 26 at Ajantā and 17 at Nāsik. On the other hand, this period sees the flowering of the Brahmanic bas-relief, which proves to have quite remarkable qualities. Brahmanism aims at showing the power and majesty of the gods (in a way quite foreign to Buddhism), by attempting to depict the cosmic, superhuman character of the gods. This is achieved by a more dynamic presentation, by making the god much taller than his acolytes and by forms such as multiple heads and arms (the first representing the omnipresence of the god and the second his omnipotence) which may seem strange to western eyes, despite the fact that they always remain perfectly balanced. A great many of the rock-hewn and free-standing sanctuaries are thus decorated with works, which, while expressing the particular qualities of each place, share a sense of divine grandeur and dignity. The most remarkable are the sanctuaries of Elephantā (an island off the coast of Bombay), which contain, apart from very fine reliefs, the famous Maheshamurti, a colossal bust with three heads of the god Shiva and the sanctuaries of Māmallapuram on the east coast of the Dekkan, which are relatively more restrained, but also more naturalistic. Māmallapuram is a remarkable group of buildings that comprises monolithic temples, excavated cave sanctuaries and a spectacular sculptural composition representing the *Descent of the Ganges* which

covers an entire rock, 88 feet in length (plate 19). There are also the sanctuaries of Ellorā, in Mahārāshtra, the decoration of which possesses great vitality, particularly in the scenes illustrating the incarnations of the god Vishnu (frontispiece) or the different aspects of the god Shiva, such as his cosmic dance. The theme of amorous human couples (*maithuna*), which appeared about the beginning of the Christian era on the façades of rock cut sanctuaries, now finds a regular place on the doorways of buildings belonging to all three religions, Buddhist, Brahmanic and Jain.

With the advent of the medieval period (ninth to the sixteenth centuries), the art of India lost much of its earlier creative impetus and the sculptor followed ever stricter iconographical rules. In Bengal and in Bihār, under the Pāla and Sena dynasties, the Gupta rules were still applied, but, having lost their former vigour, produced nothing but conventionalised types (plate 21). The earliest works, those of the eighth and ninth centuries, are free standing images set against a round-topped stele with plain backgrounds and are still very close to the post-Gupta style. There are a great many bronzes cast by the *cire perdue* (lost wax) method which apparently date from the ninth century and were made in the city of Nālanda, an important Buddhist centre at the time. They are small in size and are similar to stone sculpture, except that the stele on which they are backed is perforated, thus giving the piece a greater lightness. About the tenth century, contours of the figures are elongated and gradually become more stylised and more rigid. Their height is accentuated by the reduced height of the subordinate characters. The dress of the Bodhisattvas and Brahmanic divinities becomes more and more elaborate. Even the Buddha himself is sometimes adorned in this way, which is contrary to Buddhist doctrine. The stele also loses its simplicity and the background becomes very detailed with rearing animals, foliage and foliated motifs.

In the north of India, the tenth and eleventh centuries saw the building of many Brahmanic temples which were decorated with sculpture that was still of very fine quality (plates 23, 24). The principal centres were Khajurāho in Bundelkhand, Bhuvaneshvara and Konārak in Orissa. These sculptures, which were generally small in size, were closer to sculpture in the round than to bas-relief, for they scarcely

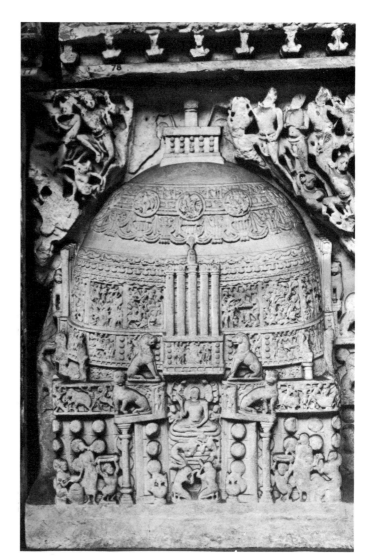

5 Bas-relief of the Amarāvati stūpa

touch the wall behind them. Their figures are slender and graceful, but their postures are often excessively contorted. The facial features are stylised, particularly the large nose and wide-open eyes, which are elongated towards the temples, thus giving them a very peculiar expression. One building may have a great many sculptures, yet every one of

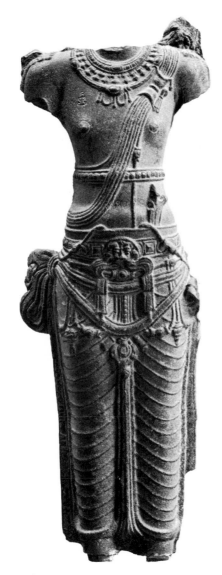

6 Statue of the god Vishnu

them varies. Most of them are of amorous couples (*mai-thuna*), even of erotic groups, due probably to the influence of certain Hindu sects such as the Tantrics for whom carnal love is an image of mystical love.

In the south, too, the walls of the temples of the Chola period (ninth to the twelfth centuries) are decorated with very fine, though somewhat austere sculpture. On the other hand, the Dravidian (southern Indian) artists of this period produced some very fine bronze images representing the gods of Brahmanism. These are notable for great purity of form, a fine, precise line and the absence of any excessive decoration. The numerous representations of Shiva Natarāja (Shiva, Lord of the Cosmic Dance) show a remarkable sense of balanced movement (plate 26). But from the Pāndya period (thirteenth to the fourteenth centuries) onward there is a decline in the work of the stone-sculptors and bronze-workers. The more they adhere to the iconographical rules the more stylised and rigid their works become.

The Islamic invasions were largely responsible for the decline of the indigenous art of India, by interrupting its development. By as early as the thirteenth century Buddhist art had completely disappeared from India, while Brahmanic art survived mainly in Rājputāna and in the extreme south. In Rājputāna, the sculpture, bas-reliefs and icons are distinguishable from the art of previous periods by the flatter treatment of the body, by a simplification of surfaces and by a deeply felt sense of rhythm and decoration. Southern Indian Dravidian art, of the cities of Vijayanagar (fifteenth to the sixteenth centuries) and Madurā (seventeenth century), evolves, on the contrary, towards a baroque elaboration. Temples built since are covered to the roofs with an entanglement of figures of multi-armed divinities that are devoid of artistic interest.

The sanctuary icons, which continued to be produced up to our own time, followed the canonical rules too scrupulously and too mechanically, with the result that they lost all their original vitality.

PAINTING

The great importance of painting (mural and 'album' or miniature painting) is mentioned in Ancient Indian literature. It was part of the education of the sons and daughters of the noble class. Like sculpture, it had its place in the decoration of the sanctuaries, but, being of its nature less durable, few works of painting have remained. Nothing, in fact, seems to have survived from the period before the Christian era. The earliest known frescos are to be found in the group of caves at Ajantā in Mahārāshtra. There are thirty of these caves (some unfinished), hollowed out of the rocky cliff that overlooks the Waghorā river, and they form

one of the most remarkable architectural groups in the whole of India. They are the work of Buddhist monks who lived there for centuries and they include sanctuaries (*chaityas*), rectangular in plan, consisting of a nave and side aisles with rows of columns and an apse, and monasteries (*vihāra*)˙ built on the plan of a simple central hall with cells usually on three sides. These caves are decorated with both sculpture and painting that cover not only the walls but also the ceilings and sometimes even the pillars. The subject of the decoration concerns either the life of the Buddha or one of his previous lives. These works consist of long compositions that unfold in uninterrupted fashion along the walls. At first sight, the different scenes seem to merge into each other and the spectator can only gradually pick out the themes that separate the different groups. The subsidiary characters often act as links, with their poses, facial expressions and gestures repeated in two different scenes. Events are not presented in chronological order, on the contrary, the artists tended to place on the same fresco events that occurred in the same place, however far apart they may have been in time. Until understood, this convention made the identification of the narrative scenes a very arduous task indeed. Although religious works of art, these may appear somewhat profane, since, in narrating the lives of the Buddha, the artist also recreates the courtly life of his period (plate 28). Long processions are depicted in which people on foot or horseback mingle with elephants passing through city gates and sumptuously dressed princes lie beneath delicate pavilions, supported by slender columns lacquered in red or blue, listening to music and watching dancing-girls. Little attention is given to landscape: the whole emphasis is placed upon the human body, whose poses and gestures are those of actors and dancers, whose vocabulary is freely borrowed and for whom every pose and gesture has a particular meaning. Calm and harmony reign supreme in these frescos and even the crowd scenes are perfectly balanced. The paintings on the ceiling (which is coffered in cave 1), for example, make use of themes taken from the plant and animal worlds that were always so dear to Indian artists.

The earliest of these caves, *chaityas* 9 and 10 and *vihāras* 8, 12 and 13 at the centre of the group, date, according to some specialists, from the second century BC The two

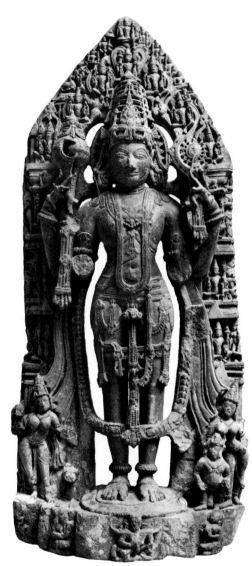

7　The god Vishnu
Carved stele

sanctuaries were decorated with paintings which have now deteriorated badly. On the right-hand wall of sanctuary 10, a long narrative frieze illustrates two of the Buddha's previous lives, the *Syama* (the young hermit) and *Shaddanta* (the elephant with six tusks — see page 10) *Jātakas*. They are related in style to the bas-reliefs of the Amarāvatī School, which allows us to dāte them from about the second and third centuries. Their technical mastery and their purity of

line and form are sufficient evidence of an art in maturity. They make little use of colour — red ochre, yellow ochre, green, black and white. The frescos that decorate the left-hand wall of sanctuary 10 and those of sanctuary 9, which are less well preserved, would seem to be a little earlier. About half the Ajantā caves were decorated with frescos, many of which have unfortunately deteriorated. The finest and also the best preserved of the groups are *vihāras* 1, 2, 16 and 17 and date from the classical age of Indian art, the Gupta period.

According to the inscriptions the entire work of the Ajantā caves — the excavation of the caves as well as the sculpted and painted decoration – was financed by devout and rich members of the royal court. It is probable that the frescos are not the work of a single artist but of a team working under the supervision of a mastercraftsman who was responsible for the total composition, executed certain parts of it and left the final carrying out of the rest to his assistants, each of whom would be a specialist in his own field. The *Vishnudharmottara*, a text written between the fourth and seventh centuries and therefore contemporary with these frescos, tells us something about the technique of these artists. Before doing anything else, the walls on which the fresco was to be painted had to be prepared. It was first of all levelled, then covered with a fairly thick coat of plaster that consisted mainly of sand, lime, clay or powdered brick mixed with rice husk and gum. This rough, porous plaster was in turn covered with white-wash, which was then carefully polished, often with an elephant's tusk. The artist could then undertake his work. First, he made a black and white sketch onto the plaster ground. He then went over it with red ochre, which was applied with a brush. These brushes, which were of different sizes, were made from animal bristle. They were used for the application of colours that were prepared with the greatest care from both minerals and plants. These were mainly red and yellow ochre, greens, white-wash, smoke-black, lapis lazuli, indigo, red lacquers and vermilion, which at the time of grinding were mixed gummy substances which enabled them to adhere better to the wall. The impression of a third dimension was created by graded areas of a darker colour emphasising the hollows. When the colours had been applied, the artist executed the decorative details. The surface was then polished once more.

Ajantā is by far the most important pictorial ensemble in India. Frescos, generally rather damaged, have survived at other sites, such as those at Bāgh in Mālva, and are slightly later than those at Ajantā and those which also decorate Buddhist sanctuaries. The frescos at Bādāmi, in the Dekkan, which decorate cave 3 (dedicated to the god Vishnu), according to an inscription, date from the year 578. This makes them the earliest known Brahmanic frescos. About sixty miles south of Ajantā is the site of Ellorā, which contains thirty-four caves, Buddhist, Brahmanic and Jain, dating from about the sixth to the ninth century. The Buddhist caves which are the earliest (550-700) were decorated with paintings of which, unfortunately, nothing survives, but the Jain cave 32, known as Indra Sabhā, has preserved its mural, which portrays flying figures. But the most important frescos are to be found on the ceiling and inner surface of the architraves of the Kailāsa, Shiva's mountain abode, a monumental sanctuary cut out of rock. These frescos seem to be contemporary with the temple (eighth century). Their treatment is more linear and they no longer possess the grace of the Ajantā paintings. These works were covered, about three centuries later, by new frescos of a quite different conception that seem to be closer to the art of the Hindi Muslim schools of Mālva and Gujarāt (see page 27). Particularly remarkable is the curious convention whereby the further distant eye of characters portrayed in profile or semi-profile is represented as full-face and protruding from the head.

In the southern Dekkan, the most remarkable frescos decorate the Jain caves at Sīttanavāsal. For many years they were attributed to the seventh century, when the caves were excavated, but it is possible that they were painted as late as the ninth century when, according to an inscription, the caves were restored. If this is the case, these paintings serve as a link between the paintings at Ajantā and those of the Chola period. The pillars of the façade are decorated with firmly-drawn celestial nymphs. A large composition which probably represents the paradise of the god Indra is painted on the ceiling of the veranda, in a lotus-pool, various animals are disporting themselves — there are fish, birds, elephants and buffalo — and three young men seen in semi-profile are

gathering flowers. The colours are less varied than at Ajantā: red and yellow ochre, green, black and white predominate.

The mural painting of the Chola period (*c.* 850-1150) is known from the frescos which decorate the interior of the great temple at Tanjore. These frescos represent scenes from the life of Shiva and possess a great sense of rhythm. The drawing, which is done in red, sometimes strengthened with black, is supple and sensitive. The later frescos are not of the same quality, but a number of paintings of the Vijaya-nagar period, such as those in the Shiva sanctuary at Le-pakchi, still have great charm.

Portable painting, which was to enjoy a great vogue in India from the sixteenth century onwards, had already existed for a long time, as we learn from such texts as the *Kāmasūtra*, which lists the contents of the paint-boxes belonging to young nobles: pencils, brushes of various thicknesses, vessels containing paint powders. This was not only an art of the court. According to the *Harshacharita*, travelling art galleries mounted on wheeled carts moved around the country-side and the *Ashokavadana* mentions the travelling story-tellers, who, as they recited their verses, illustrated the story with the aid of a rolled painting on canvas on two bamboo poles held in their left hand, pointing out the different scenes with a reed. In the Buddhist monasteries the same method was used to narrate different episodes in the life of the Bud-dha. These paintings were done on cloth, wooden panels or palm-leaves, for paper was only introduced into India about the twelfth century. It seems to have been imported from Persia, but probably originated in China.

No album painting (commonly called miniature painting) earlier than the eleventh or twelfth centuries has survived. The oldest known manuscripts are Buddhist and came from Bengal and Bihār (plate 30). They were written and painted onto long, narrow palm-leaves, generally measuring about 21 inches. These leaves were placed on top of each other and held together by a string running through the middle of the leaves and the two pieces of wood which served as covers and which were painted on the inside. These leaves were sometimes decorated with a miniature, usually measur-ing about 3 inches by 2½ inches. Such manuscript paintings of the Pāla period are of an elegant and refined style that derives from that of the Ajantā frescos.

From western India (Gujarāt, Rājputāna, Mālvar) came manuscripts that were kept in the Jain libraries. They were executed on palm-leaves between the twelfth and fourteenth centuries and their format is similar to that of the Buddhist manuscripts of Bengal. The calligraphy is done in black, but the style of their miniatures is very different — much more linear and vigorous. The compositions on red or blue back-grounds are simple and few colours are used: yellow, white and green. The often stylised figures are drawn in profile or semi-profile, the further eye protruding over the cheek as in the paintings of the Kailāsa.

From the fifteenth century, most manuscripts were exe-cuted on paper (plate 31), though palm-leaf manuscripts were still to be found. The best size for these manuscripts was about twelve inches by four inches, allowing space to be given to illustration, which retained the same character-istics while becoming more ornamental — probably under Moslem influence. Gold and ultramarine were used and the text itself was sometimes inscribed in silver or even in gold on a red background. The most widespread texts were the *Kalākācharya Kathā*, the story of the Jaina monk Kalāka, and the *Kalpasūtra*, an account of the life of Mahāvīra, the founder of Jainism.

The methods used by the artists of the different schools of miniature painting whether purely Indian or Mughal, follow very closely the technique of mural painting. Paper made from silk, cotton, linen, bamboo or jute was used. After polishing the surface for a long time with an agate ball, the design was sketched in with a fine brush. This was then covered with a thin layer of white, on which the artists went over the outlines with a black line. The paint was then applied and the detail completed.

At the beginning of the sixteenth century, Moslem rulers in India introduced Persian miniatures in the Turkoman style, which had been centred on Shirāz, a city in southern Persia. This gave new impetus to the art of the miniature. Persian or Indian artists applying the principles of this Tur-koman school worked in Mālva. An illustrated manuscript, the *Nimat-Namah*, or 'book of delicacies' was particularly remarkable. Its landscapes — clumps of grass and flowers, foliage, wreaths of cloud, rocks, blossoming trees — are typical of the school of Shirāz, whereas some of its female figures

are closer to the art of western India.

A small but important group of paintings has been attributed to Mewār, a kingdom in Rājputāna that flourished in the fifteenth and sixteenth centuries until the sack of the fortress at Chittor by the Mughal emperor Akbar in 1568. These paintings seem to date from the first half of the sixteenth century. They are illustrations of Indian poems: the *Chaurapañchāshikā*, 'The fifty Stanzas of the Thief', a Sanskrit love poem; the *Gīta Govinda*, a poem about Krishna as Govinda the cowherd and his loves with the milk-maids, and the *Laur Chanda*, a popular ballad from northern India. These miniatures, set against a matt background, are simple in composition. A few elements set the scene — a pavilion, trees — but the whole decorative attention is centred on the richly-dressed figures.

The Moslem dynasty of the Mughals established its domination over northern India during the sixteenth century. At the court of the emperor Akbar (1556-1605), Indian artists, working under the direction of Iranian painters, executed the great historical works commissioned by Akbar. Notable among these works was a *Hamza-Nāmeh*, the illustrations of which were painted on cloth, a *Razm-Nāmeh* (or 'Book of the Wars', a translation into Persian of the great Indian epic of the *Mahābhārata*), the *Akbar-Nāmeh*, the *Tarikh-i-Alfi* (the history of the world written in the form of annals) and the *Bābur-Nāmeh* (plate 32).

The vitality and spiritual energy of the Indian artists collaborating with those of an Iranian background from the court of the Sefevids, vitalised the Mughal school which at the same time benefited from the reciprocal influence of the union of two quite different traditions and conceptions. To these elements must be added a European influence, from engravings and paintings brought to the Mughal court by Jesuit missionaries. This influence is apparent in a greater naturalism in the style of the landscapes, particularly in the use of perspective. Western engravings were occasionally copied by the Mughal artists. The painters of this school usually drew their subjects from court scenes, hunting or battles, but they also illustrated fables and natural history. Many of the miniatures of the Akbar period are signed. They however were seldom the work of a single artist but generally of a team, in which one painter

was responsible for the composition, another actually applied the paints and a third specialised in portraiture. We can thus identify a few of the Indian artists who worked at the Mughal court; foremost among these were Daswanth, Basāwan and Miskīna.

With the reign of Jahāngir (1605-1627), there is a change in miniature painting, particularly to subject matter. Flowers, birds (plate 33) and animals are given greater prominence and are represented over a whole page instead of being merely subordinate elements. One of the most remarkable artists in this kind of miniature was Mansūr. But also popular were court scenes and portraits which were executed in profile or semi-profile against a rich background, often turquoise blue or dark green. There were no innovations under the reign of Shāh Jahān (1628-1658); portraits of the nobility continued to abound, the tendency to idealisation that had appeared in the Jahāngir period also continued and the draughtsmanship remained very fine (plate 34).

During the reign of Akbar, provincial schools under the patronage of nobles existed beside the imperial schools. The art of these regional schools was the sole work of local artists and was overshadowed by the quality of the work of the princely courts. When the emperor Aurangzeb came to the throne, it was the nobles who helped to protect the artists from his fanatic persecutions. The Mughal miniature was thus able to survive, but it no longer possessed the charm and finesse it had had early in the seventeenth century.

Nothing is yet known of the painting of the Moslem courts of the Dekkan prior to the Mughal period. But its style, in which both the Hindu and Moslem traditions come together, emerged quite independently. These works, whose colours are brighter than those of the Mughal school, came chiefly from three main centres, Ahmadnagar, Bijapur (plate 35) and Golconda, which were in close relations with each other. The Persian influence seems to have been a direct one in these courts, which had political and economic links with Persia. The painting of the Dekkan seems to have reached its height between 1565 and 1627. Although it continued to show a great decorative sense and a taste for rich detail, there was subsequently a certain loss of vitality.

In the seventeenth century a special kind of painting developed at Ahmadnagar. This painting was used to illus-

trate poems written to accompany musical compositions. These works were known as *rāga* and *rāgini* (the *rāga* being the six basic modes in which Indian music was written and the *rāgini* the five secondary modes into which each *rāga* was divided). These highly poetic works were to reach their height in Rājputāna (in the State of Mewār), which resisted Moslem domination and kept the Hindu civilisation alive for a long time. In the seventeenth century, under the reigns of the two great rulers, Jagat Singh (1628-1652) and Rāj Singh (1652-1681), a great many religious and epic books were illustrated at Mewār. Very often they celebrated the cult of the god Krishna, whose famous loves with milk-maids are the symbol of the mystical union of the soul with its god (plate 37). These miniatures are remarkable for their simplicity of composition, their precision of execution and their juxtaposition of bright, warm colours. They seek to express a mood.

At this time there were many different schools of painting in Rājputāna, each possessing its own style, but sharing a common feeling for rhythm and symbolism. Apart from the school of Mewār, the most important in the seventeenth century seem to have been those at Marwār, Bundī and Mālva (plates 38, 39).

From the eighteenth century, an interaction between the Mughal school and the schools of Rājputāna became obvious In the states of Mewār and Marwār, Mughal influence was apparent in the refinement of style and in the choice of subject — portraits of the sovereigns and their courts (plate 40). On the other hand, in the state of Bikaner, where Mughal artists had settled, a Rājput-Mughal style developed (plate 41). In two states the style remained more original. In Kishangarh, the king's studio was directed by Nihāl Chand. An exceptional painter, he had a style which attempted to convey passion through idealisation, rhythm and beauty. He perpetuated the style of the preceding period, but it was not to last very much longer (plate 41). In the state of Kotah, tiger hunting became a favourite theme. The hunt is depicted as taking place in a jungle landscape where there are also other animals, which, as always in Indian art, are drawn with great naturalness and sense of observation.

From the eighteenth century, the most important development of the Rājput miniature was in the centres of the Punjab known as '*pahāri*' ('of the mountains') where schools of painting had appeared only towards the end of the seventeenth century. The oldest of these, known as the school of Basohli (plate 43), is found not only in Basohli itself but also in the neighbouring states of Jammū, Chambā, Nurpur and Guler. In its choice of subjects concerning the cult of Krishna and in its use of bright, warm colours, the Basohli style is close to that of Mewār and it is possible but not certain, that its appearance was due to the arrival in the hill states of the Punjab of artists from Mewār. The Basohli style continued into the middle of the eighteenth century, but it lost some of its intensity of feeling and its colours lost much of their brilliance. The sack of Delhi by Nadir Shāh of Persia in 1739, introduced into the other Punjab hill states Mughal artists who brought about a sudden change in *pahāri* painting. This change first became apparent in the two centres of Jammū and Guler. The painting of Jammū is above all an adaptation of the Mughal style to the taste of the High Punjab. At Guler and probably in the surrounding centres there developed a more original style that is especially well known for its portraits and for religious scenes in which Krishna plays a dominant role. It links a taste for rhythm with naturalism and is particularly characterised by its representation of the female figure as a woman both graceful and grave.

Between 1770 and 1823, *pahāri* painting was developed into the Kāngrā style which was to survive until 1905 when an earthquake destroyed this centre and killed most of its artists. The Kāngrā style continued the Guler style and helped to spread the Guler ideal of the female (plate 48), but in doing so it also lost much of the quality that Guler painting had had in its beginnings. Miniature painting known as the Garhwal style seems to have been contemporary with that of Guler; some painters from Kāngrā had moved to Garwhal in the nineteenth century. Typical of the Garwhal style is a female type with a sharper profile and its composition is more romantic in feeling (plate 47).

From the nineteenth century, there was a decline in the quality of Indian miniature painting. However, a movement, which was started at the end of the century and in which the Tagore family played a very active role, tried to revive Indian pictorial art by studying the lessons that could be derived from its past.

Notes on the illustrations

Figure 1 Frontispiece: *Narasimha*. High relief decorating the cave of the 'avatāra', at Ellorā. 7th century.

The god Vishnu, depicted in one of his *avatāra*, his incarnation as a man-lion, emerges from a column to punish the blasphemer who had dared to deny his existence. This scene is very well balanced and makes no attempt to incite terror. The god's strength is emphasised simply by his eight arms and his lion's face.

Figure 2 *Lion capital of Ashoka.* Polished sandstone. Height 6 ft. 10¾ in. (210 cm.). 3rd century BC. Museum of Sārnāth.

This capital surmounted a column on the shaft of which was carved an edict of the emperor Ashoka. The lions probably have an imperial and solar symbolism, while the wheels separating the four animals in bas-relief that decorate the drum symbolise the Law.

Figure 3 *Bas-relief from the hand-rail of the railings of the Stūpa at Bharhut.* Sandstone. Height 1 ft. 10½ in. (57 cm.). About 2nd century BC. Calcutta Museum, Calcutta.

Within the sinuous line of a drooping lotus stem flowers alternate with scenes depicting figures. This scene represents the adoration of the *bodhi* tree by the stags. Flowers have been arranged on the altar-throne at the foot of the tree. The cult of the sacred tree, which plays an important part in Buddhism, had existed in India previously. The stags are treated very naturalistically.

Figure 4 *Decorative ivory bands.* Found at Begrām (Afghanistan). Height from ¾ in. to 2¼ in. (2 to 6 cm.). About 2nd century. Musée Guimet, Paris.

These bands show to what extent the ivory-workers had mastered their art. The decoration is of vegetable and animal inspiration. It is either engraved with an engraver's point, or carved with the undecorated parts cut away in order to give a slight relief to the decorated part, or fretted. The animals, as in all Indian art, show great powers of observation, as in the geese with spread wings or the ducks on the water.

The classical theme of the garland gave rise to a particular decorative motif — this consists of dragons with elongated bodies and withered legs that form a continuous garland.

Each of these dragons is swallowing the tail of the one in front. Within the loops of the garland are human figures below and eagles with outstretched wings above.

Figure 5 *Bas-relief of the Amarāvatī stūpa.* Marble limestone. Height 4 ft. 6½ in. (138 cm.). About 3rd century. British Museum, London.

The simple, hemispherical stūpa of the early period that had developed from the funeral piles of the Vedic period has developed still further. It shows a richness of decoration that is no longer content merely to decorate the railings but invades the monument itself: bas-reliefs depicting scenes in the lower part, a band of medallions, garlands, pendentives in the upper part. The entrance is guarded by four lions, where a scene is depicted: the adoration of the Buddha sitting on the serpent (*nāga*) Muchilinda.

Figure 6 *The god Vishnu.* Sandstone statue of the Chola style. Height 3 ft. 1½ in. (95 cm.). About 11th century. Musée Guimet, Paris.

The god is wearing a wide flat necklace, decorated with stylised motifs and a *dhoti*, secured at the waist by a belt, with a buckle at the front in the shape of a monster's head. A scarf tied around the hips is knotted on the right and falls forward in concave folds. The torso is surrounded by a pearl belt.

Figure 7 *The god Vishnu.* Hoyshala style. Basalt. Height 3 ft. 5¼ in. (105 cm.). 12th century. Musée Guimet, Paris.

The god, who is very tall, stands out from the fretted stele, which forms a background. He holds the usual attributes of Vishnu, the disc and the conch shell. He is flanked by his wives, Lakshmī and Bhumidevī, the earth goddess. On the stele itself, the gods Brahmā and Shiva, the ten *avatāra* of the god and his twelve secondary forms are represented.

THE PLATES

Plate 1 *Mother Goddess.* Pink terra-cotta. Height 7 in. (18 cm.). Maurya period, rd century BC. Musée Guimet, Paris.

This terra-cotta statuette, probably depicts the Mother Goddess, the symbol of fertility, protectress of all beings and creator of life, whose cult seems to have been common to the

ancient religions of India, Iran and the Near East. Similar statuettes have been found in the sites of the Indus civilisation. The representation of the figure is very stylised: the clothes are indicated only by a few incised strokes and the hair is built up into a kind of turban, decorated with three rosettes.

Plate 2 *'Yaksha'*. Red sandstone. Height 2 ft. 8¾ in. (83 cm.). Shunga period, 2nd to 1st century BC. Musée Guimet, Paris. The heavy form of this statue and the care with which the details of the five row pearl necklace have been executed are characteristic of early Indian sculpture in the round. It depicts a *Yaksha*, an air-spirit, whose cult was very popular in India (well before the Christian era) for they were thought to bring prosperity and well-being. *Yaksha* were adopted by Buddhism and became the guardians and defenders of the Law. They are generally depicted as being plump and jovial.

Plate 3 *Necklace and ear-rings*. Gold. Length 1 ft. 3½ in. (39 cm.); diameter 1¾ in. (4 cm.). South India, 2nd century BC. Musée Guimet, Paris. The few examples of jewellery that have survived from early times confirm that Indian artists of this period were very fine goldsmiths. This is seen in the meticulous reproduction of jewellery in sculpture, both in the round and bas-relief. These chestnut-shaped ear-rings and this necklace were discovered in a Megalithic sepulchre at Souttoukeny, near Pondicherry, in southern India. The necklace consists of two unsoldered beaten chains, converging on a cluster of lotus petals to form a 'y' shape.

Plate 4 *Upper half of a pillar of the railings from the Bodhgayā Stūpa*. Height 3 ft. 10 in. (116 cm.). About 2nd century BC. Victoria and Albert Museum, London. The railings around the stūpa were decorated with bas-reliefs either of a decorative or didactic character. Thus this pillar shows a lotus-shaped medallion, within which is carved a winged elephant and a scene from one of the Buddha's previous lives (*jātaka*). The elephant is presented as a mythical animal, being treated in a quite unnaturalistic fashion, despite the fact that Indian artists were masters at the representation of animals. The particular *jātaka* has not been identified with

any degree of certainty. The seated figure is almost certainly a king on his throne, behind which stands a female courtier. A third figure is approaching the king, probably in order to present him with what he is carrying on his shoulders.

Plate 5 *Yakshinī holding a branch of the ashoka-tree*. Sculpture from the great stūpa of Sāñchī. Height 2 ft. 2½ in. (67 cm.). About 1st century AD. British Museum, London. The *Yakshinī*, or female *Yaksha*, are air-spirits and inhabit trees. They are also regarded as ogresses who are prone to child-eating. This *Yakshinī* has her arm round the trunk of the flowering ashoka-tree. She is wearing a draped *dhoti*, secured at the hips with a four-row pearl belt, a pearl necklace and a row of rings around her arms and ankles.

Plate 6 *Ivory statuette*. Indian origin, found in the ruins of Pompei. Height 9¾ in. (25 cm.). 1st century AD. Museo Nazionale di Capodimonte, Naples. The discovery in the ruins of Pompei of this finely-carved statuette, representing a female character and two child attendants, is proof that Indian objects found their way into the Roman Empire. The style of this statuette is related to that of Sāñchī (plate 5); it has the same belt formed of rows of pearls and the same rings on the arms and legs, not only of the principal figure, but also of her attendants.

Plate 7 *Part of a chair back*. Ivory. Height 9 in. (23 cm.). From Begrām (Afghanistan). About 2nd century. Musée Guimet, Paris. This joint decorated a chair of a type represented on the bas-reliefs of Mathurā and Amarāvatī. The rectilinear summit of the back projected slightly over the uprights, to which it was connected by two symmetrical, arc-shaped joints. The joint shown here is carved on both sides and represents a woman astride the long, thin body of a leogryph (a fabulous animal), which is emerging from the wide open jaws of a *makara* (sea monster). The middle of the animal's body is very curved so that the woman's body hardly projects beyond the outline

Plate 8 *Pillar of the railings of a stūpa*. Red sandstone, Height 2 ft. 3¾ in. (70 cm.). From Mathurā. 2nd century. Musée Guimet, Paris.

Pilgrims to a religious sanctuary had to make a ritual circum-ambulation around the stūpa to show their devotion. The pillars of the stūpa railings were decorated on the inside, either with bas-reliefs depicting scenes from the life of the Buddha or from his previous lives, or with tall figures like the Buddha shown here, which possesses all the characteristics of the Mathurā school: a round face, shaved head covered by a skull-cap and the monastic cloak draped over the left shoulder, leaving the right shoulder bare. The outside of this pillar, however, has a purely decorative character: medallions in the form of stylised lotuses, such as are frequently to be found in the Indian art of this period.

Plate 9 *Pillar of the railings of a stūpa.* Red sandstone. Height 1 ft. 8 in. (51 cm.). From Mathurā. 2nd century. Victoria and Albert Museum, London.
This pillar is decorated with the same theme as plate 5. The Yakshinī, or tree goddess, is a popular subject in Indian iconography and literature.
With her slim waist, wide hips and full bust, this Yakshinī is a superb example of the ideal of female beauty existing in the India of this period. Like the Yakshinī of Sāñchī, she is wearing a hip belt of pearls to secure her transparent garment, but this belt has a gold buckle at the front, and her fore-arms are almost entirely covered with rings. She is clasping the branch of a tree with one hand raised above her head. Her position — the triple flexion — is particularly graceful.

Plate 10 'Nāgarāja' — the serpent-king. Red sandstone. Height 3 ft. 9¾ in. (116 cm.). Mathurā school. 2nd century. Musée Guimet, Paris.
Like that of the *Yaksha*, the cult of the *nāga*, or water spirits, is of popular origin. It was particularly widespread in the Mathurā region. The *nāga* were attributed with the power of causing rain and, therefore, of both fertility and destruction by flooding. They were soon adopted by Buddhism and play a great role in early Buddhist legends.
This *nāga*-king is particularly remarkable for its fullness of form, its suppleness of movement and its harmony of line, which are well brought out by the material out of which it is carved: the dark red sandstone of the Mathurā region.

Plate 11 *The attack of Māra.* Bas-relief from a stūpa at Ghantashala. Marble limestone. Height 5 ft. 9¾ in. (177 cm.). School of Amarāvatī. About 2nd century. Musée Guimet, Paris.
This bas-relief still belongs to the earliest Indian iconography. Although the Buddha is the principal character in the scene, he is not actually represented; nevertheless, the numerous pilgrims who saw this bas-relief would have had no difficulty in recognising the scene represented — the attack of the Buddhist demon Māra (riding an elephant), against the Buddha, who sits in meditation prior to finding the way of the salvation of the world — for the empty throne at the foot of the tree and the imprint of the two feet (between the legs of the throne) are enough to indicate the Buddha's presence.

Plate 12 *Bas-relief from a stūpa at Nāgārjunakonda.* Marble limestone. Height 4 ft. 1¼ in. (125 cm.). School of Amarāvatī. 3rd century. Musée Guimet, Paris.
This bas-relief depicts a Buddhist legend (*avadana*). King Udayana of Kausāmbī, having gone to sleep under the influence of drink, finds on waking that his wives are no longer around him. They have deserted him in order to go and listen to the preaching of the monk Pindola. The king is furious and prepares to attack the saint (the scene on the right), but his wives manage to calm him and he kneels down beside the monk (the scene on the left).
The graceful curves of the bodies of the figures, especially of the women, are characteristic of the Amarāvatī School.

Plate 13 *Bodhisattva from Shabaz-Garhi* (West Pakistan). Shale. Height 3 ft. 11¼ in. (120 cm.). From the 'Graeco-Buddhist' School of Gandhāra. About 2nd century. Musée Guimet, Paris.
The cult of the Bodhisattva, symbols of supreme charity, became popular at the beginning of the Christian era. They resemble princely characters and wear traditional dress: a long loin-cloth and a full cloak.
The Bodhisattva of the Gandhāra School is very close to Hellenistic art in the draping of the clothes, but the manner of wearing the cloak over the left shoulder, wrapped around the left arm and leaving the torso bare is very Indian. He wears a great deal of jewellery, sandals secured by pearl laces and

a highly-decorated turban, tightened at the back by ribbons that float down from the halo. On the pedestal is represented the adoration of the Buddha's begging-bowl, which is placed on a throne beneath a dais.

Plate 14 *The Bimārān Reliquary*. Chased gold encrusted with rubies. Height 2¾ in. (7 cm.). School of Gandhāra. About 2nd century. British Museum, London.
Like all the work of the School of Gandhāra, this finely-wrought little reliquary is very Hellenistic in style, but the iconography of the characters and the form of the arches are Indian.

Plate 15 *Head of a monk*. From a Buddhist monastery at Hadda (Afghanistan). Stucco. Height 4¾ in. (12 cm.). School of Gandhāra. About 3rd to 4th century. Musée Guimet, Paris.
The stucco works of the Gandhāra School are much more vivacious and less academic than those in shale. This monk's head, with its expression of intense interior concentration, seems to be a real portrait.

Plate 16 *Gupta-style Buddha*. Sandstone. Height 4 ft. 9½ in. (146 cm.). About 5th century. British Museum, London.
The Buddha, holding the hem of his monastic dress with his left hand, while his right hand is raised in the gesture of the absence of fear. The lower garment, which falls to the ankles, is secured at the waist by a knotted cord, the ends of which fall over the left thigh. The very light dress, which is transparent in order to reveal the body, shows the predilection of the Gupta artists for the nude. Only a fragment remains of the large, circular halo (decorated with foliated scrolls), that is attached to the shoulders.

Plate 17 *Head of the Bodhisattva Avalokiteshvara*. Red sandstone. Height 6 in. (15 cm.). Gupta style. About 5th century. Musée Guimet, Paris.
This head is very characteristic of the Gupta art of Mathurā. Avalokiteshvara, the merciful Bodhisattva, whose cult was particularly important in India, is shown here wearing a royal or princely diadem that is made up of a jewelled border and a puff. On this there is a small Buddha, seated in the Indian

manner, flanked by two lions, with upright horns and garlands of pearls streaming from their mouths.

Plate 18 *Torso of a Bodhisattva*. From Sāñchī. Red sandstone. Height 2 ft. 10¼ in. (87 cm.). Gupta style. 5th century. Victoria and Albert Museum, London.
This Bodhisattva is wearing princely dress, a *dhoti*, decorated on the upper part with foliated scrolls and secured at the waist with a figured belt. The buckle of the belt, which is placed in front, is in the form of a monster's head. The Bodhisattva is also wearing a broad necklace of a stylised floral design. However, over his left shoulder and across his chest, he is wearing the dress of a monk — an antelope's skin, complete with head and with its paws tied together.
The perfect proportions of this torso show the mastery of the artists of this period in the representation of the human body.

Plate 19 *'The Descent of the Ganges'*. Detail of relief from Māmallapuram. 7th century.
This relief entirely covers a great isolated rock that serves as the dike of a lake. It depicts an Indian legend: the descent on earth of the holy waters of the Ganges. A natural flaw in the rock was used to represent the river, symbolised by nāga with human busts and serpents' bodies. Each detail is interesting in itself, though the unity of the composition is achieved by the convergent movements of the figures, human and animal, towards the river. On the left are monks; one of whom is in meditation near a temple dedicated to the god Shiva, others are practising various mortifications or drawing water. Among the monks are certain animals, deer, hind and tortoises. On the right is a majestic elephant, above which are flying air-spirits — they too wish to go to the sacred river.

Plate 20 *Sculpted column base*. Sandstone, Height 3 ft. 7 in. (190 cm.). About 9th century. British Museum, London.
This column base is decorated with eight dancing girls in high relief, set in arches formed by rounded pillars and surmounted by stylised monsters' heads (*kirti-mukha*). The dancers are wearing the *dhoti* and scarf and jewellery: large, circular ear-pendants, necklaces, bracelets and ankle rings.

Their poses are very graceful, but they are treated less sensitively and with less vitality than in the works of the Gupta period.

Plate 21 *The marriage of Shiva*. Pala-style stele. Sandstone. Height 2 ft. 1½ in. (64 cm.). About 10th century. British Museum, London.
This Shivaite stele illustrates the marriage of the god Shiva and the goddess Parvatī — an episode described by the poet Kalidāsa in his poem *Kumarsambhava* (VII, 74-80). The god and goddess are holding hands; near them, but on a much smaller scale because they are not the principal figures, stand the god Vishnu and an attendant, who is holding a receptacle; sitting in front of them is the god Brahma tending the sacrificial fire. Parvatī is holding a mirror in her left hand and Shiva, who is depicted with four arms, is holding a lotus and a trident. The base is decorated with figures of dancers, musicians and the bull Nandi, the god's steed, while the upper part depicts the seven planets and the demons Rāhu and Ketu, whose mutual hostility is the cause of eclipses.

Plate 22 *Bodhisattva sitting in meditation on a lotus*. Pala style. Gilt bronze. Height 7½ in. (19 cm.). 11th century to 12th century. Musée Guimet, Paris.
This Bodhisattva is wearing a *dhoti* and checked scarf, a diadem with three tall fleurons, a necklace with three pendants and ankle-rings. The fretted back forms a halo round the Bodhisattva's head, whose decoration consists of a monster's head at the top, two winged sea-monsters (*makara*) and two upright leogryphs spitting garlands of pearls.

Plate 23 *Mother and child*. Red sandstone. Height 1 ft. 3¾ in. (40 cm.). Orissa style. About 10th century. Musée Guimet, Paris.
Small in size, like most of the sculptures that decorate the walls of the Orissa temples of the medieval period, this fragment of high relief has all the grace and charm of the finest works of this period.

Plate 24 *Shiva dancing*. Stele. From the temple of Bhuvaneshvara. Sandstone. Height 3 ft. 5¼ in. (104 cm.). About 12th century. British Museum, London.
This stele represents the god Shiva (Natarāja) dancing the cosmic dance that symbolises both the creation of the world and the victory of Knowledge over Ignorance.
The god is shown standing on a lotus beneath a multifoiled arcature; with his two upper hands he is holding two serpents whose bodies form a kind of arch over his head. He is wearing the usual jewellery, but the Brahmanical cord is replaced by a serpent. Shiva is flanked by two small assistants in the same dance pose and by two musicians playing drums; two more musicians, one playing the trumpet and the other the cymbals, are positioned on either side of the lotus. Behind the god, his steed, the bull Nandi, depicted, like the two assistants, on a smaller scale, is raising its head to him.

Plate 25 *Divine couple*. From a temple at Khajurāho. Sandstone. Height 2 ft. 1¾ in. (65 cm.). About 11th century. Archaeological Museum, Khajurāho.
This is one of the many groups that bring so much life to the walls of the temple at Khajurāho. Their gracious poses, the firm relief of the torsos, the facial expressions, the large eyes stretched slightly towards the temples are characteristic of the sculpture of this period.

Plate 26 *Shiva dancing*. Dravidian bronze. Height 5 ft. ½ in. (154 cm.), including pedestal. 12th to 13th century. Museum van Aziatische Kunst, Amsterdam.
Bronze sanctuary icons are very common in South India. The representations of Shiva Natarāja are particularly remarkable for their sense of balance and movement.
Shiva is shown here with the flaming halo. As he dances, his right foot is crushing the dwarf, the symbol of Ignorance. With his two upper hands, he is carrying his attributes — on the right, the drum shaped like an hour-glass (*damaru*); on the left, fire (*agni*). The locks of his hair extend symmetrically from either side of his head and touch the halo; the goddess Gangā, the personification of the sacred river Ganges, stands on one of these locks, facing the god, her hands joined in a sign of adoration.

Plate 27 *Chandikeshvara*. Dravidian bronze. Height 21⅝ in. (55 cm.). 13th-14th century. Provost & Fellows, Eton College.

Southern India is particularly devoted to the saints, whether Vishnuite or Shivaite. Among the latter, Chandikeshvara is particularly popular. He is regarded as the guardian of the temples dedicated to the god Shiva. He is shown standing, hands joined, in an attitude of adoration.

Plate 28 *Fresco painting decorating Cave I at Ajantā*. Detail of the fresco in the sanctuary of the cave. 5th to 6th century.
Facing the central statue of the Buddha, this Bodhisattva forms a triad with the Buddha and the bodhisattva painted on the opposite wall. He is holding a lotus in his right hand. Behind and around him are light-skinned and dark-skinned female figures, dwarfs and monkeys, whose presence helps to emphasise his own serene spirituality, so characteristic of the Buddhist works of the Gupta period.

Plate 29 *Girl Dancers and Musicians*. Detail of a fresco decorating the left wall of the entrance to Monastery I of the Ajantā caves. 5th-6th centuries. (Photograph taken from a copy by G. C. Haloi and not from the fresco itself.)
Music and dancing were two arts particularly appreciated by Indians of every period and were often used as subjects by Indian artists. The detail shown here is part of the illustration of one of the Buddha's previous lives, the *Mahājanaka jātaka*. The orchestra consists of two transverse flutes, two pairs of cymbals, a pair of bulbous drums and one sandglass shaped drum.

Plate 30 *Buddhist manuscript of the Bengal School*. 2½ in. 1 ft. 10 in. (67 × 56 cm.). Last quarter of 11th century. Bodleian Library, Oxford.
This manuscript is composed of palm leaves bound between covers of painted wood. The cover and pages are decorated with illuminations, depicting scenes from the life of the Buddha or figures of Bodhisattvas. At the centre of the cover is Prajnaparamitā the personification of wisdom, and to whom the manuscript is dedicated. She is shown seated on a throne, making the teaching gesture and holding her attributes, the rosary and the book. She is flanked by two rows of five seated goddesses, all holding the philosopher's stone (*cintāmani*) in the right hand, with the exception of the goddess on the extreme right who is making the gesture of favour with her right hand

and holding the lotus stem in her left. On this leaf the Supreme Buddha, Vajrasattva, is in the centre, holding the *vajra*, thunder, and a small handbell. On either side is a Bodhisattva: on the left Maitreja makes the gesture of teaching with her hands and holds a lotus stem on which stands the vessel of water; on the right, Vajrapani holds the *vajra* in the right hand and the stem of a lotus in the left.

Plate 31 *The consecration of Mahāvira*. Miniature illustrating a Jaina manuscript, the *Kalpasūtra*, that dates from 1404 and comes from Gujarat. 3 × 4 in. (7 × 10 cm.). British Museum, London.
This miniature depicts the consecration of Mahāvira, the founder of the Jain religion. Dressed in a *dhoti*, and still wearing jewellery, Mahāvira is tearing out his hair; before him, the god Shakra is holding a trident (his divine and royal characteristics are indicated by the halo and the parasol). According to the text, the scene takes place in a very high place, which is why mountain peaks are represented in the lower part of the picture. The two figures are shown in three-quarter profile, but the far eye is represented frontally and projecting beyond the cheek, according to a convention that particularly characterised the Gujarāti miniature and which was previously to be found in the mural painting of the Kailāsa at Ellorā.

Plate 32 *The emperor Bābur inspecting a garden*. Page from a manuscript of the 'Bābur Nāmeh'. Miniature of the Mughal School. 11½ × 6½ in. (29 × 16 cm.). Last quarter of the 16th century. British Museum, London.
The *Bābur Nāmeh*, the memoirs of the emperor Bābur, the founder of the Mughal dynasty, was painted during the reign of Akbar and is still close to the manner of the Persian miniature. The landscape, in particular, is very Persian: the rocks, the blossoming tree beside the stream bordered with stones, the palace in the upper part of the picture. However, the gardeners in the foreground, shown in the middle of their work, clearly belong to Indian tradition; the treatment of the water in the stream is also Indian. The influence of European artists is apparent in the cloud effects. Although the manuscript is undated, the miniatures that decorate it seem to have been painted between 1595 and 1600.

Plate 33 *Falcon*. Miniature of the Mughal School, Jahāngir period. 4⅝ × 7½ in. (11 × 19 cm.). First quarter of the 17th century. British Museum, London.

The Emperor Jahāngir had a particular feeling for nature. He loved to observe animals and, especially, birds and he built up a vast collection of studies of birds and flowers. This falcon on its perch, standing out in profile against a green background, is treated in great detail.

Plate 34 *The three sons of Shāh Jahān*. Miniature of the Mughal School. 15 × 10¼ in. (38.7 × 26 cm.). About 1637. British Museum, London.

From the inscription at the bottom, this miniature would seem to be the work of Balchand, a painter of the reign of Jahāngir. But it has also been attributed to Bichitr, painter to Shāh Jahān. The miniature represents the three princes Shujā, Aurangzeb, and Murād Bakhsh riding across the countryside. They are shown in profile, against a hilly landscape, but the interest is centred solely on them. Their clothes, their plumed turbans, their weapons – spear in the right hand and sword in belt, the harness of their horses are all treated with the naturalism that characterises the Mughal School under the reign of Shāh Jahān.

Plate 35 *Portrait of a Prince*. Miniature of the School of Golconda (Dekkan). 7¼ × 4½ in. (18.6 × 11.3 cm.). About 1680. Victoria and Albert Museum, London.

This miniature is of the Muslim king of the State of Bijapur sitting on a rock at the foot of a lightly-leaved willow. The rock is treated in the Persian style as is also the ground dotted with clumps of small flowers. In his right hand he is holding a red flower, the colour of which stands out against his white dress. With his left hand he is leaning on his circular shield, over which one can see the hilt of his blue-scabbarded sword.

Plate 36 *Couple on a terrace*. Miniature of the School of Dekkan. 10¾ × 7 in. (27 × 18 cm.). Middle of the 18th century. Musée Guimet, Paris.

The prince is leaning back on to a large cushion the design of which is similar to that of the magnificent carpet on the terrace. Near the prince are his weapons and a few refreshment goblets. The young woman is offering him one of them.

This miniature is remarkable for its sense of composition and its taste for rich detail. The influence of the Persian artists is very marked in the treatment of the landscape: trees and flowering shrubs in the background, flower-beds around a pool in the foreground.

Plate 37 *Krishna and Radhā*. Miniature of the School of Mewār. 12 × 9⅔ in. (29 × 24 cm.). About 1645. Victoria and Albert Museum, London.

Like many miniatures of this school, it concerns the famous love of the god Krishna for his favourite wife Radhā. It is divided into two registers, the upper part representing the meeting of the two lovers, with Radhā going out to meet Krishna, who, in the lower part, draws her to the couch on the right. The scene takes place at night as is shown by the dark blue sky and crescent moon. The uniform background, with juxtaposed areas of flat painting, is typical of Mewār.

Plate 38 *Kedara Rāginī*. Miniature of the School of Bundi. 9 × 5½ in. (23 × 14 cm.). About 1640. Victoria and Albert Museum, London.

The music paintings, the *rāgā* and *rāginī*, express a musical theme and are the pictorial interpretation of poems written on this theme. This miniature depicts a monk holding a musical instrument and sitting beneath a pavilion. Opposite him is a pilgrim holding a rosary in his right hand. The pilgrim is learning the ascetic positions, as is shown by the band around his left knee and the stick under his right shoulder. His sandals are placed behind him. There are ducks in the lotus pond in the foreground and the peacock on the pavilion roof is a symbol of love.

Plate 39 *Todī Rāginī*. Miniature of the School of Mālva. 11⅔ × 8¼ in. (29 × 21 cm.). 17th century. Victoria and Albert Museum, London.

This miniature is also a music painting (see plate 38) corresponding to a different melody, the Todī Rāginī. It depicts a girl musician, with a tall, slender figure, holding a vīnā, an Indian musical instrument. She stands out against a hillside, on the top of which there is a pavilion, with birds flying around it. She is awaiting her lover and the gazelles around her, like the lotus pond in the foreground, are symbols of

love. In the upper part of the miniature is a floral border.

Plate 40 *The Rāja Ajit Singh.* Miniature of the School of Marwār. 8¾ × 11 in. (22 × 28 cm.). About 1725. Victoria and Albert Museum, London.
The Rāja is shown surrounded by his sons and grandsons. Under the influence of the Mughals, these portraits of the royal family were fashionable in Rājput courts of the 18th century. The rāja, who is smoking the hookah and holding a flower in his right hand, is lying back on a large cushion. A servant, standing in front of him, is carrying a sword, a goblet and a bottle. His sons and grandsons have their swords near them and also hold flowers. They are all wearing very full and very tall turbans, typical of the State of Marwār.

Plate 41 *Queen and her buck.* Miniature of the School of Bikāner. 5⅔ × 3 in. (14 × 7 cm.). 1731. Victoria and Albert Museum, London.
In its style and in its subject — a young woman holding her favourite buck on a lead — this miniature is very close to the Mughal School. The woman is shown in profile against a uniform background. In the foreground, the ground is indicated by a wavy line and a few clumps of herbs. It is signed Ahmad Muhammad and dated 1731.

Plate 42 *Muni Shri Sukdevji preaching to the Rāja Parikshit, urging him to renounce his throne.* Miniature of the School of Kishangarh. 8½ × 12½ in. (21 × 31 cm.). About 1757. Victoria and Albert Museum, London.
The scene takes place in a landscape of lake and hills whose treatment owes a great deal to the Mughal influence of the Aurangzeb period. It contains a number of picturesque scenes: barges, horsemen, animals. In the foreground, the rāja, accompanied by a large following, has left his throne to the monk. The monk, his head surrounded by a halo, is entirely naked (as was the custom of the adepts of the Jain sect of the Digambara), except for a garland of flowers, probably a gift of homage from the rāja, around his neck. To the right of the rāja, a musician is playing the vīnā and there is a huntsman holding his bow and an arrow he has just taken from his quiver.

Plate 43 *Shivaite monk approaching the god Krishna in a grove.* Miniature of the School of Basohli. 9 × 12½ in. (22 × 31 cm.). About 1695. Victoria and Albert Museum, London.
This miniature illustrates a text concerning the cult of the god Krishna. Its bright, fresh colours and the treatment of the landscape and figures are typical of the Basohli style. The two figures are wearing the same dress: the *dhoti* and scarf. The god can be recognised by his dark blue complexion — dark blue being the colour of the god Vishnu, of whom he is the incarnation. He is wearing sandals, whereas the monk is barefoot. The monk has his hands joined in an attitude of adoration.

Plate 44 *Nobles and dervishes.* Miniature of the School of Kulu. 6¾ × 10⅝ in. (17.1 × 26.7 cm.). About 1680. Victoria and Albert Museum, London.
A Rājput prince, wearing a plumed turban, with a dagger in his belt, is holding his falcon on his gloved hand. Falconry was one of the favourite sports in the Rājput courts. Opposite him, in Indian file, stand a dervish (Muslim priest), holding a fan of peacock feathers and a prince, whose left hand is resting on a large sword pointing to the ground, while his right hand is fingering a rosary. A second dervish seems to be playing on a musical instrument. All four are wearing long robes flared out at the bottom.

Plate 45 *The holī festival.* Miniature of the School of Chamba. 10½ × 8⅔ in. (26 × 22 cm.). About 1775. Victoria and Albert Museum, London.
In the middle, the god Krishna, recognisable by his dark blue complexion, is standing with his favourite wife, the milkmaid Radhā. They are taking part in the spring festival, the holī, a festival celebrated at the beginning of the hot season, in the course of which young men and women throw coloured powders at each other and, with bamboo syringes, squirt each other with red and yellow water in large receptacles.

Plate 46 *Durgā slaying the demon Mahishāsura.* Miniature of the School of Nurpur. 7½ × 11 in. (19 × 27 cm.). About 1765. Victoria and Albert Museum, London.
The mythological subject of this miniature concerns the fight

between the buffalo demon Mahisha, chief of the *asura* (demons) and the goddess Durgā, wife of the god Shiva. The goddess is astride her lion, who takes part in the fight. Once the buffalo-head has been cut off, the *asura* reverts to its human form and tries to defend himself by brandishing his sword and shield, but the goddess will pierce him with her trident and an arrow she is about to shoot at him. The scene takes place in a setting of wooded hills in which does are frollicking about.

Plate 47 *Queen awaiting her lover*. Miniature of the School of Garhwāl. 10½ × 8½ in. (26 × 21 cm.). About 1785. Victoria and Albert Museum, London.
On a terrace, a young woman, lying on a bed, is being prepared by her servants, who busy themselves around her; one of them is fanning her, another offers her a goblet and others are holding a tray on which there is a bottle and a box. A blossoming tree shows a Persian influence, whereas on the hills in the background there are a number of small, round trees.

Plate 48 *The swing*. Miniature of the School of Kangrā. 8½ × 5½ in. (21 × 14 cm.). About 1810. Victoria and Albert Museum, London.
A serious, yet graceful young woman, of a type very characteristic of the School of Kangrā, is sitting on a swing. The theme of the swing symbolises love and is associated with threatening clouds in the sky, which also suggest desire. The swing is a very ancient theme in India, where, ever since the Vedic period, it was both an entertainment and a rite. It is associated not only with love, but also with spring.

Chronological table

DATES	HISTORICAL EVENTS	ART
About 2500-1500 BC	Indus civilisation	Painted pottery Inscribed seals Statuettes
About 1500-500 BC	Arrival of the Aryans Vedic India	
6th century BC	Evolution of Vedism towards Brahmanism Foundation of Buddhism and Jainism	
End of 4th century – 1st century BC	Expedition of Alexander the Great Maurya dynasty Sunga dynasty	Ashoka Pillars Earliest Buddhist art Stūpas; excavated sanctuaries Buddha represented by symbols
1st-4th centuries AD	Kushāna dynasty Andhra dynasty	Appearance of the image of the Buddha Graeco-Buddhist art The Mathurā style The Amarāvatī style
4th-6th centuries	Gupta dynasty	Gupta style, the high point of Indian art Beginning of Brahmanic art First free-standing temples
8th century	Beginning of the Arab invasions	Post-Gupta style Pallava style Pāla style
12th century	End of Buddhism in India Foundation of the Sultanate of Delhi	Late Buddhist works of the Pāla style Dravidian style
14th-16th centuries	Moslems in the Dekkan Dravidian kingdom of Vijayanagar	Indo-Persian art Dravidian style
16th-18th centuries	Mughal empire	Indo-Persian art Mughal and Rajput schools of miniature painting Dravidian style

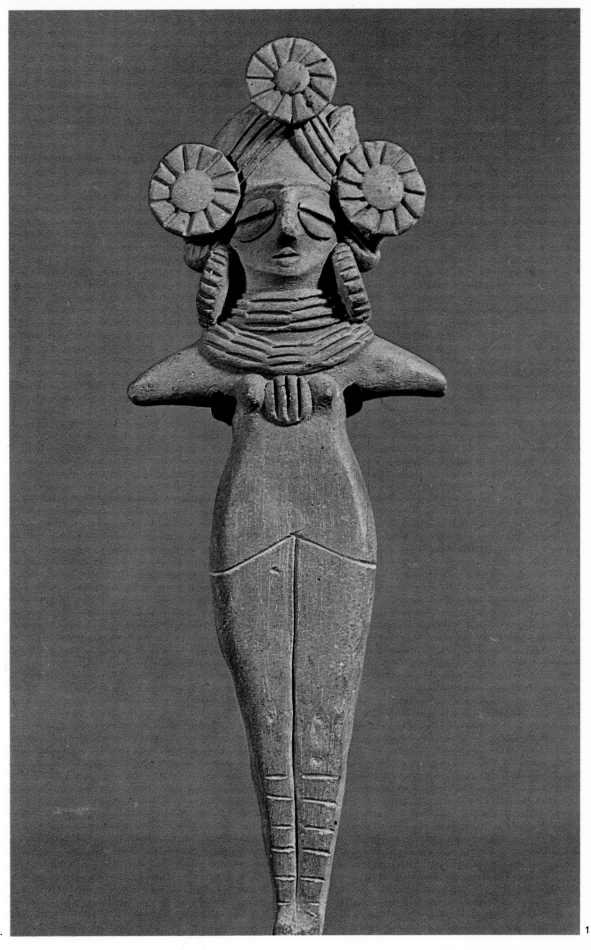

Mother Goddess statuette.

1

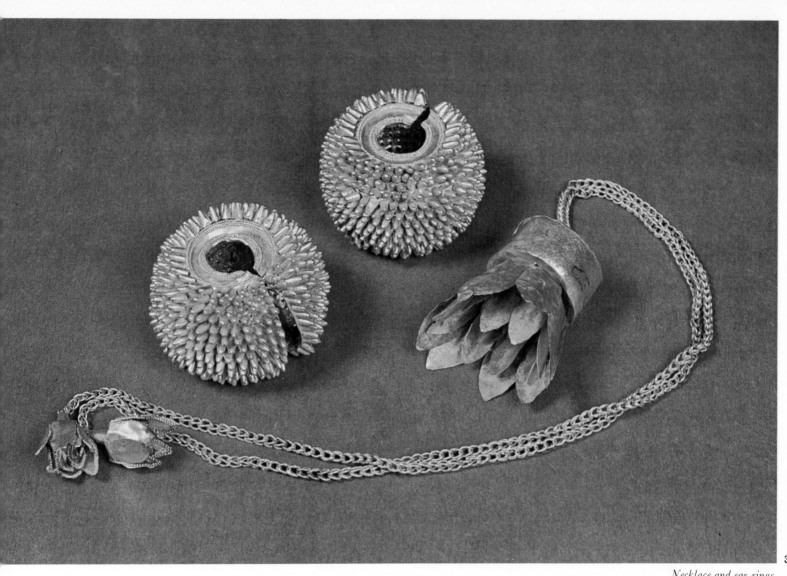

3

Necklace and ear-rings.

ft) *Statue of a 'Yaksha'.*

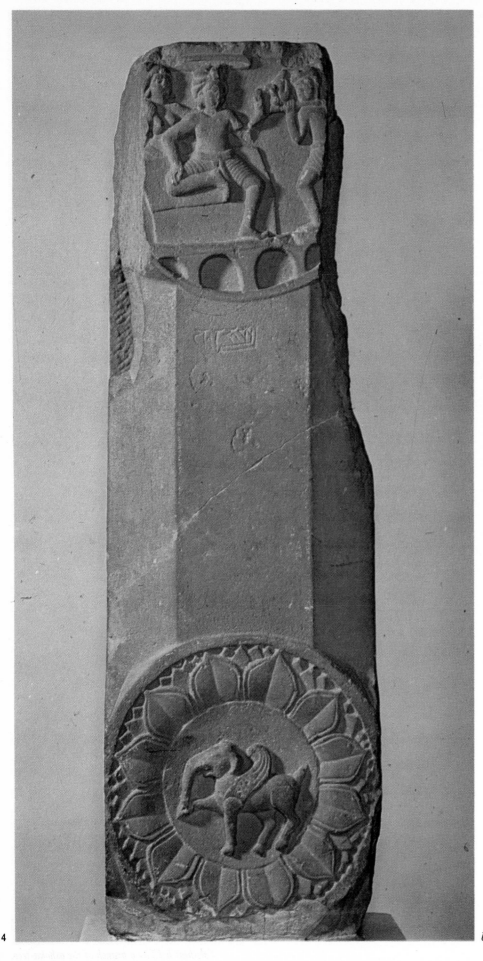

4

Upper half of a pillar of the railings from the Bodhgayā Stūpa.

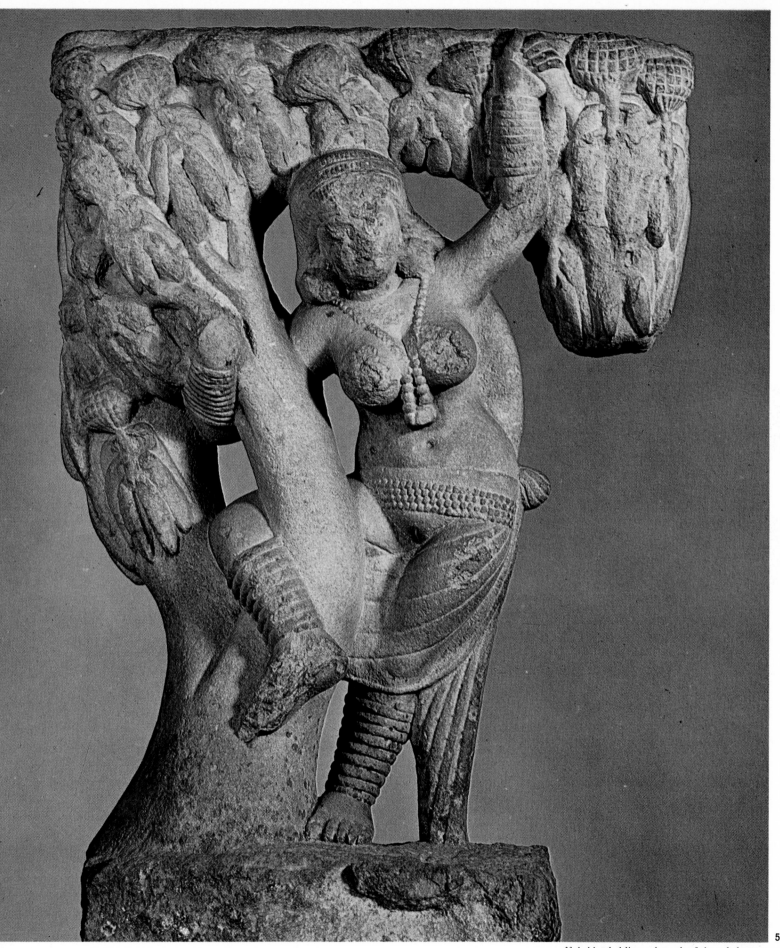

Yakshinī holding a branch of the ashoka-tree.

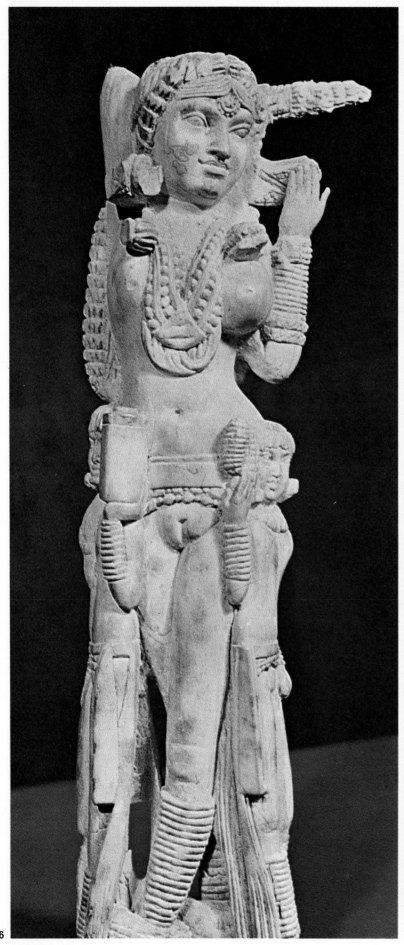
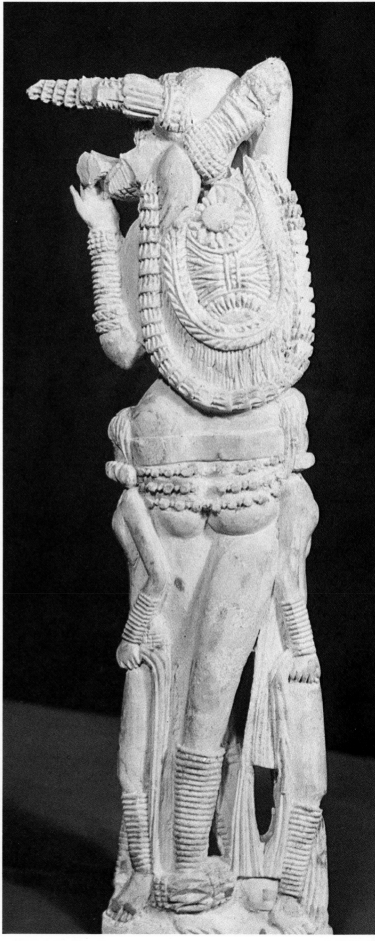

6
Ivory statuette.

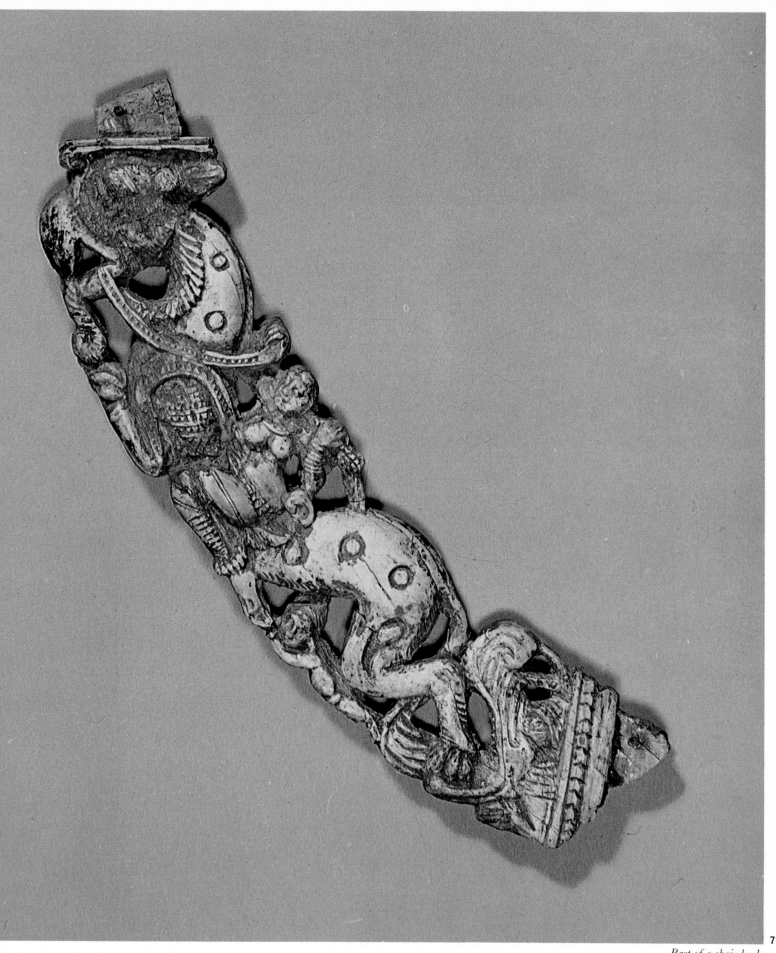

7

Part of a chair back.

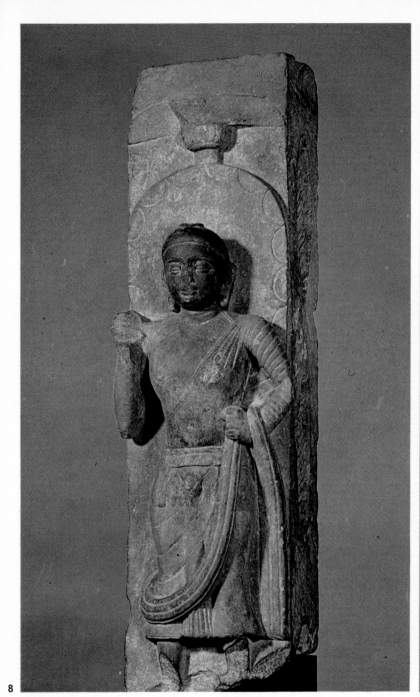

8

Pillar of the railings of a stupā.

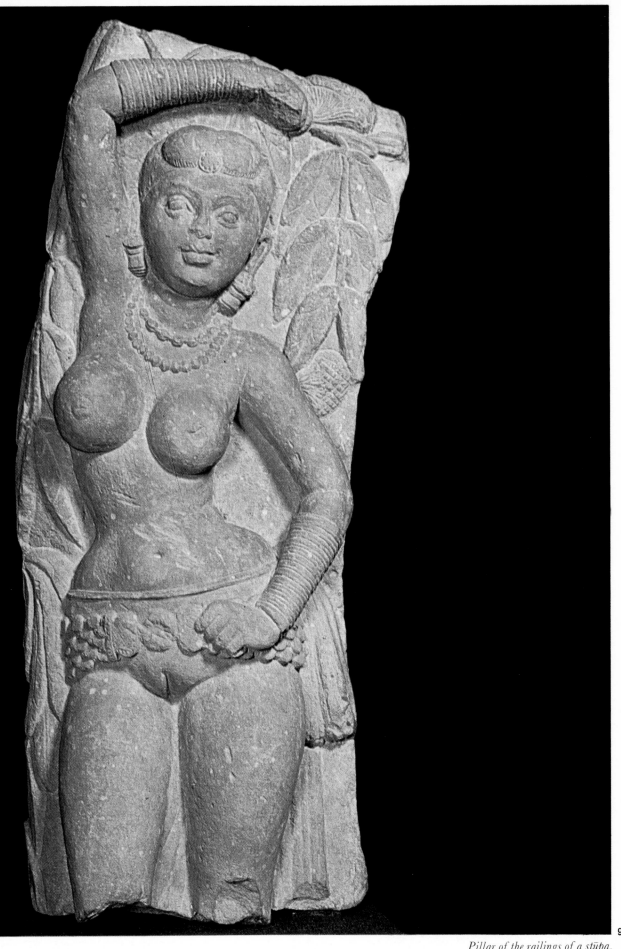

Pillar of the railings of a stūpa.

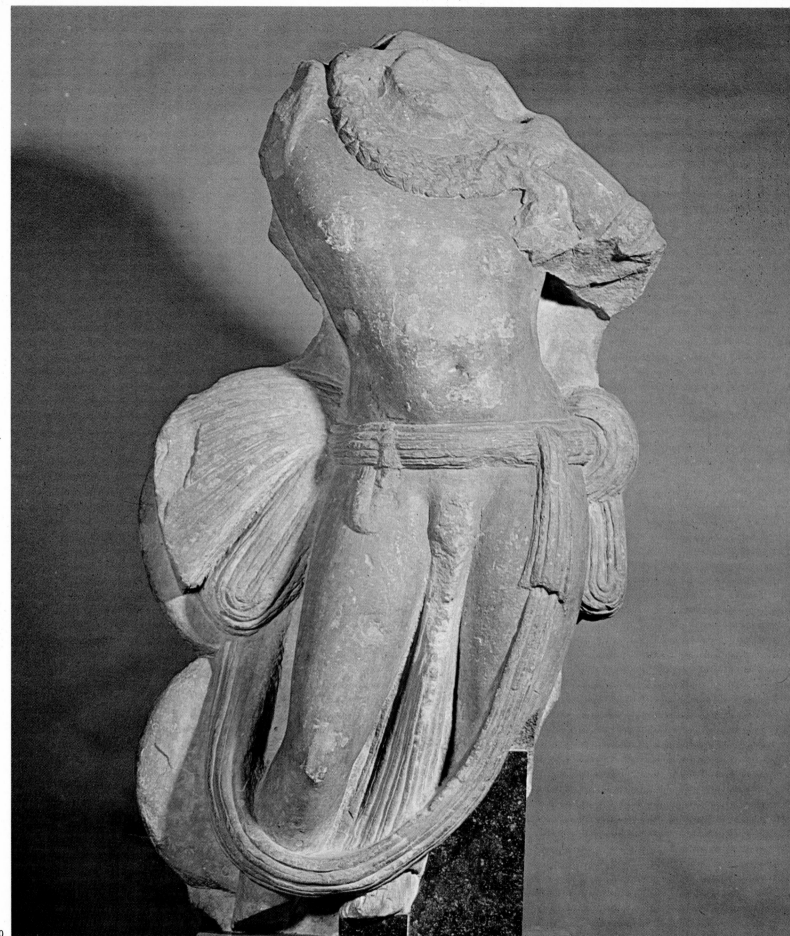

10
'Nāgarāja' the serpent-king.

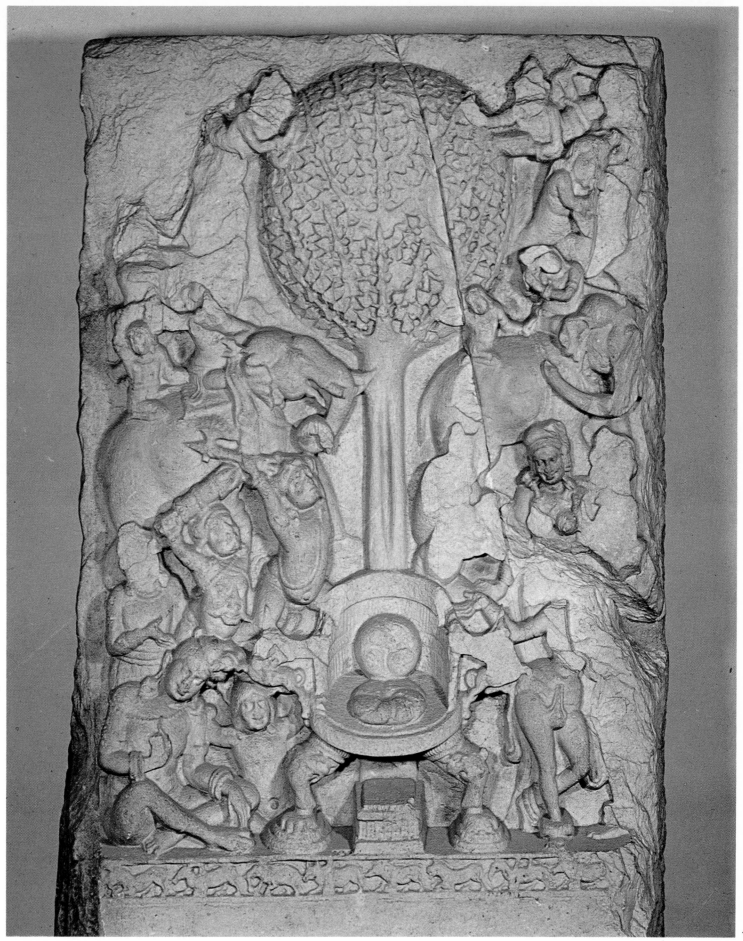

The attack of Māra.

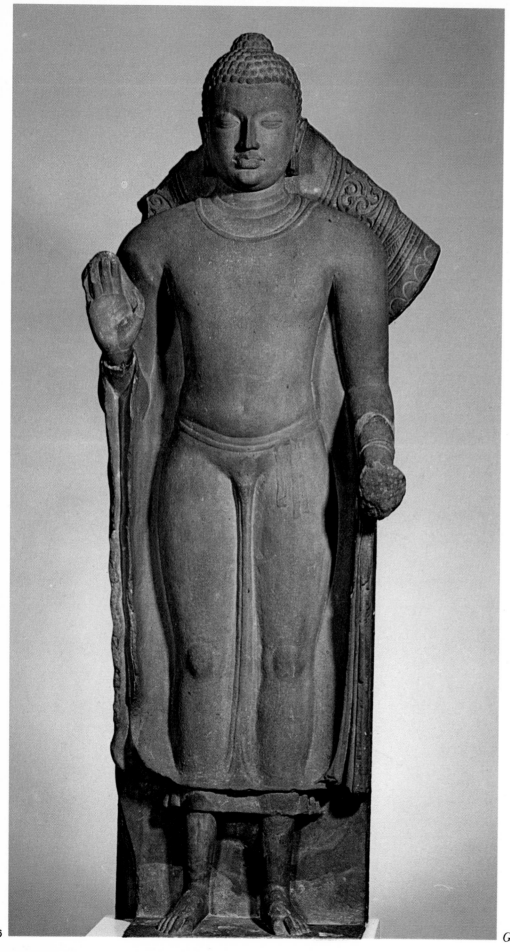

16

Gupta-style Buddha.

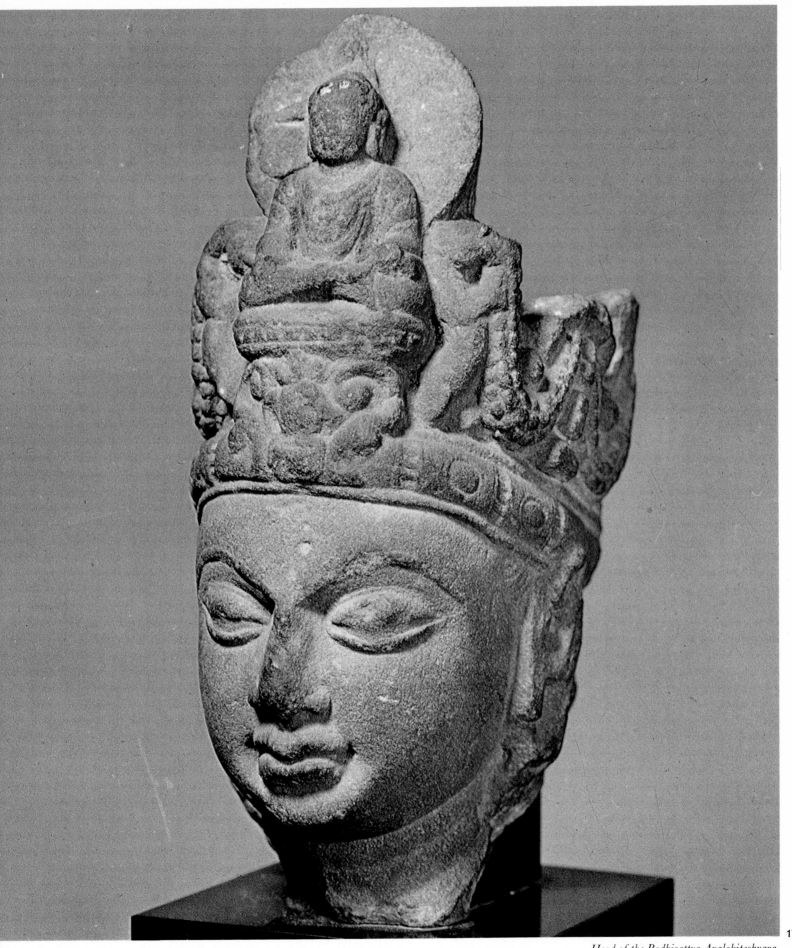

Head of the Bodhisattva Avalokiteshvara.

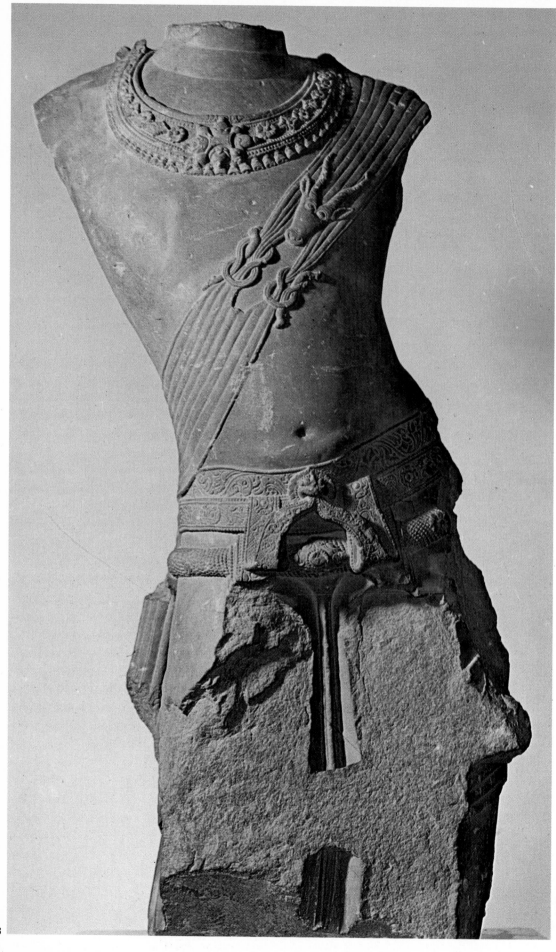

Torso of a Bodhisattva.

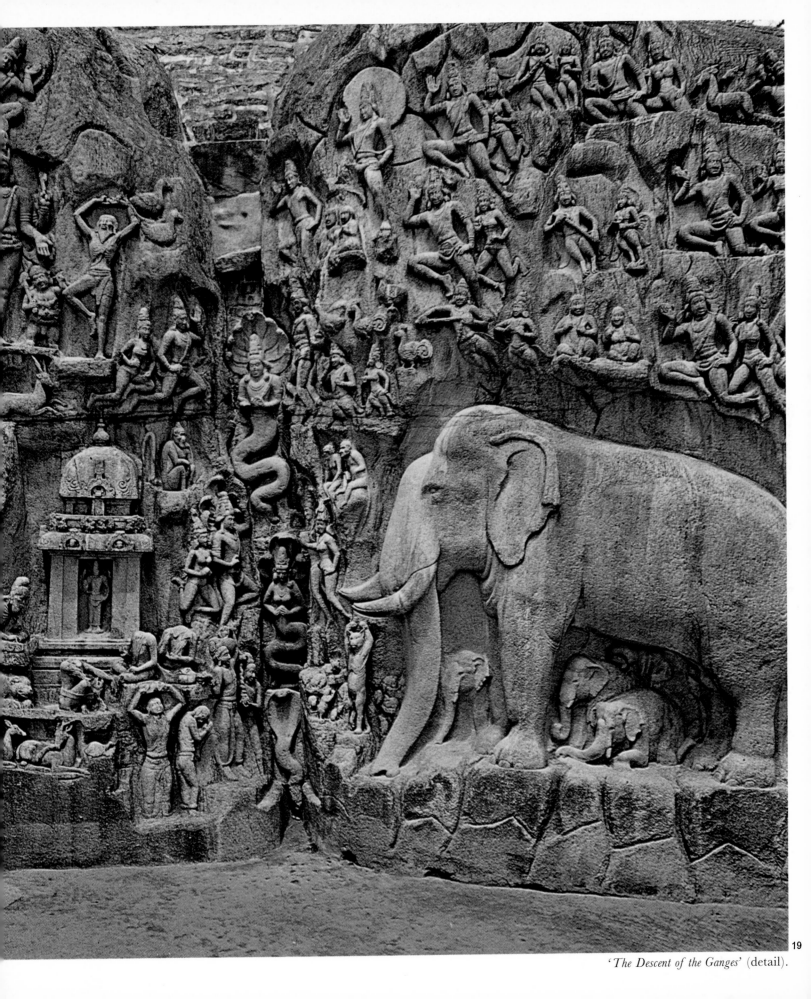

'The Descent of the Ganges' (detail).

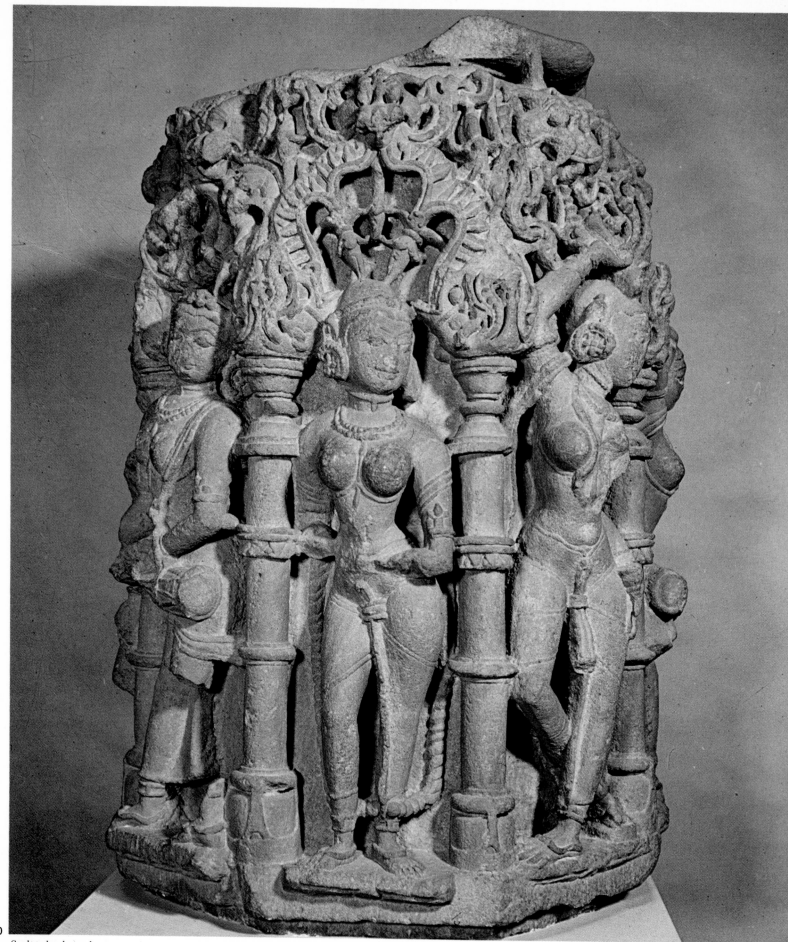

Sculpted column base.

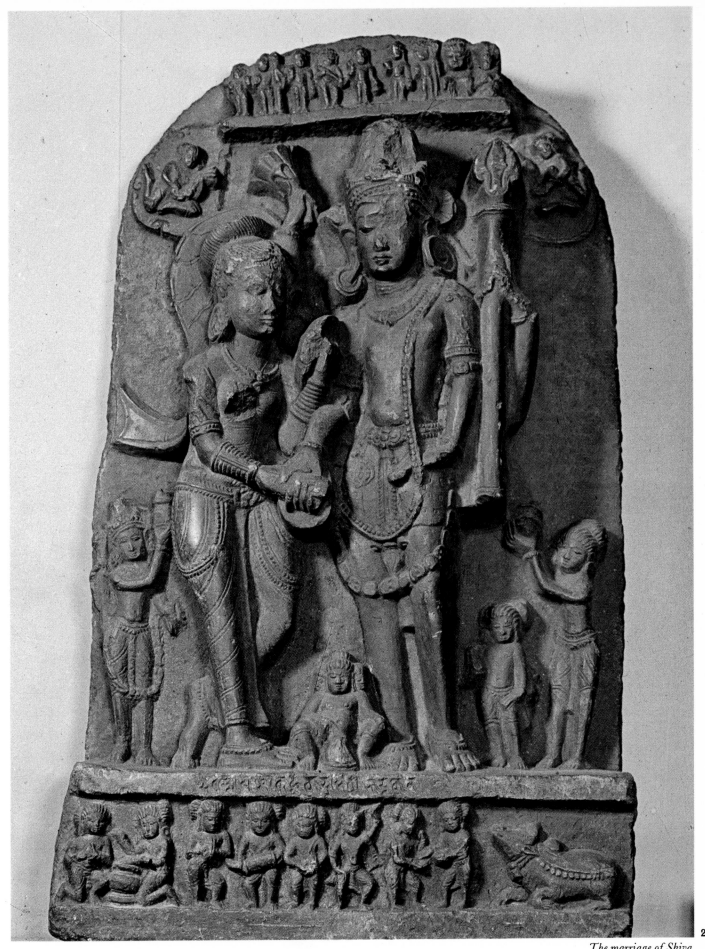

21

The marriage of Shiva.

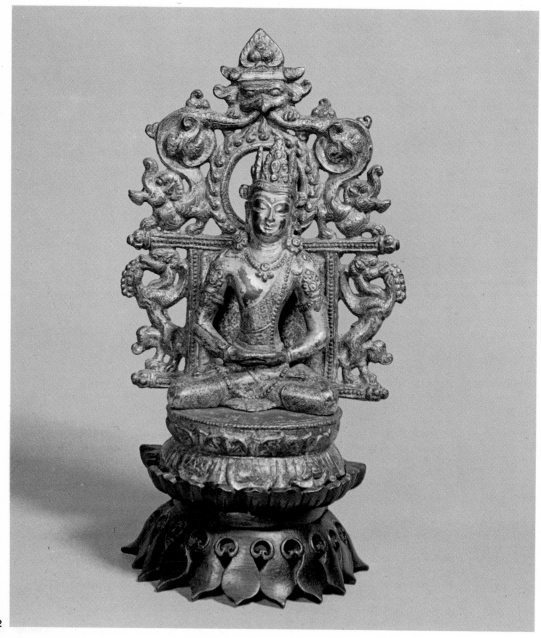

Bodhisattva sitting in meditation on a lotus.

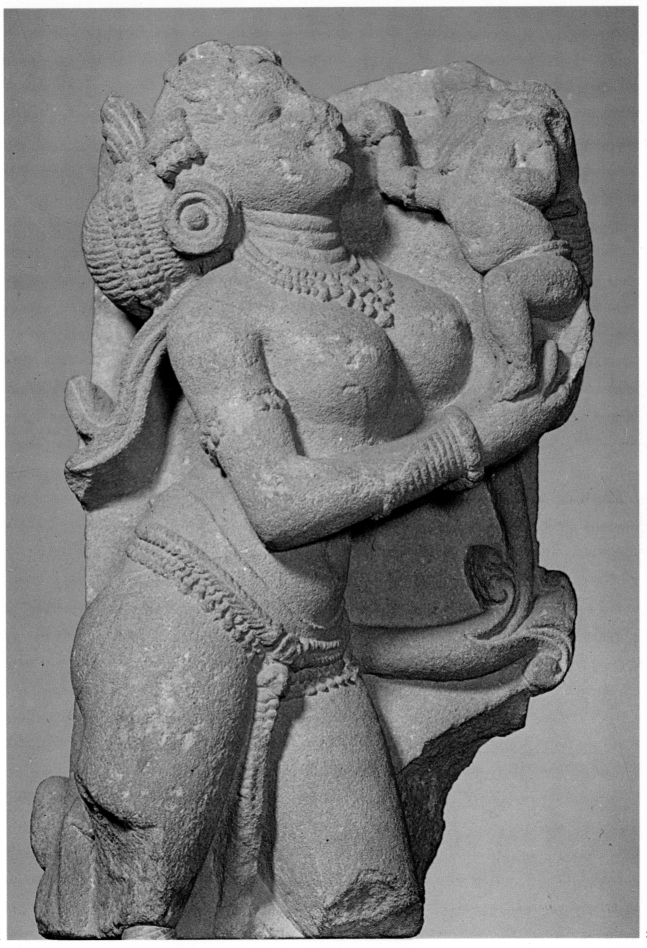

Mother and child.

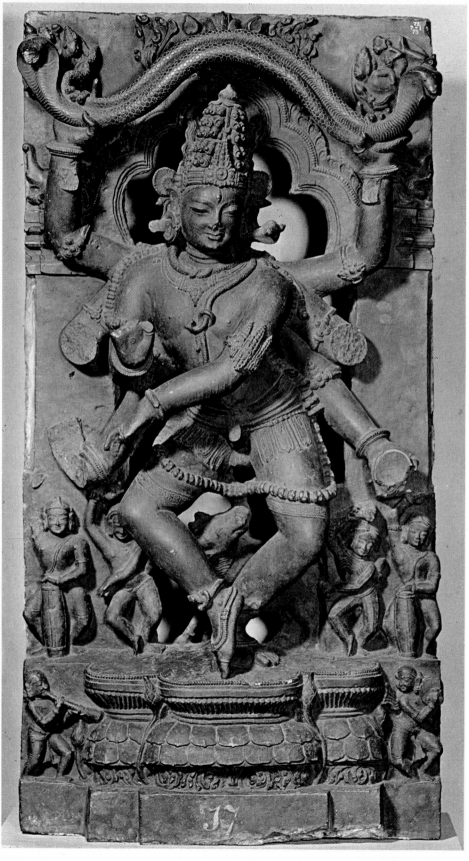

24

Shiva dancing.

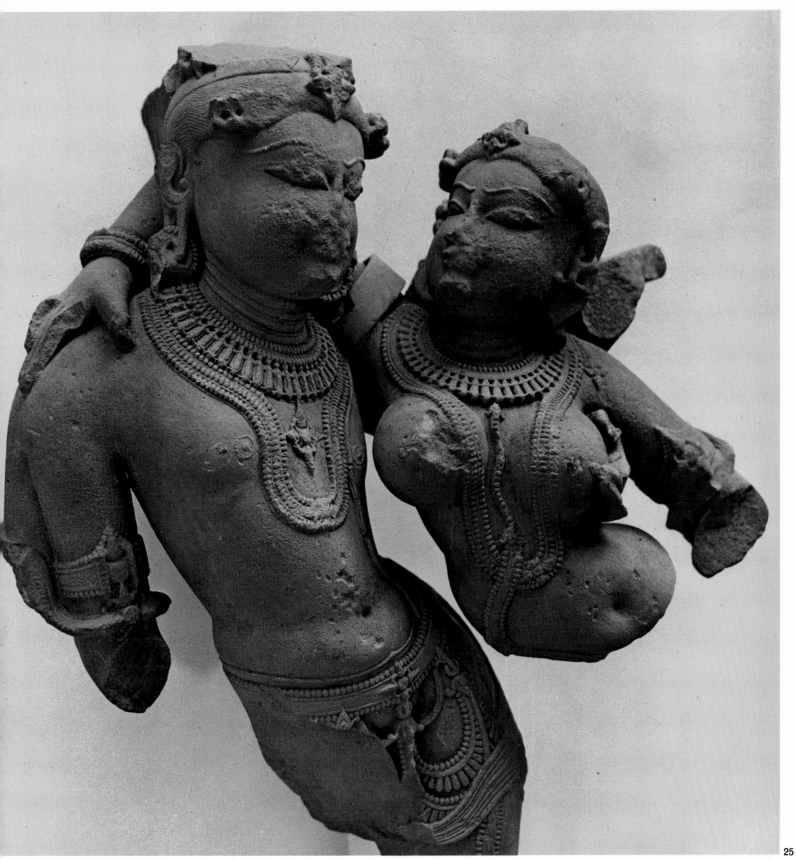

25

Divine couple.

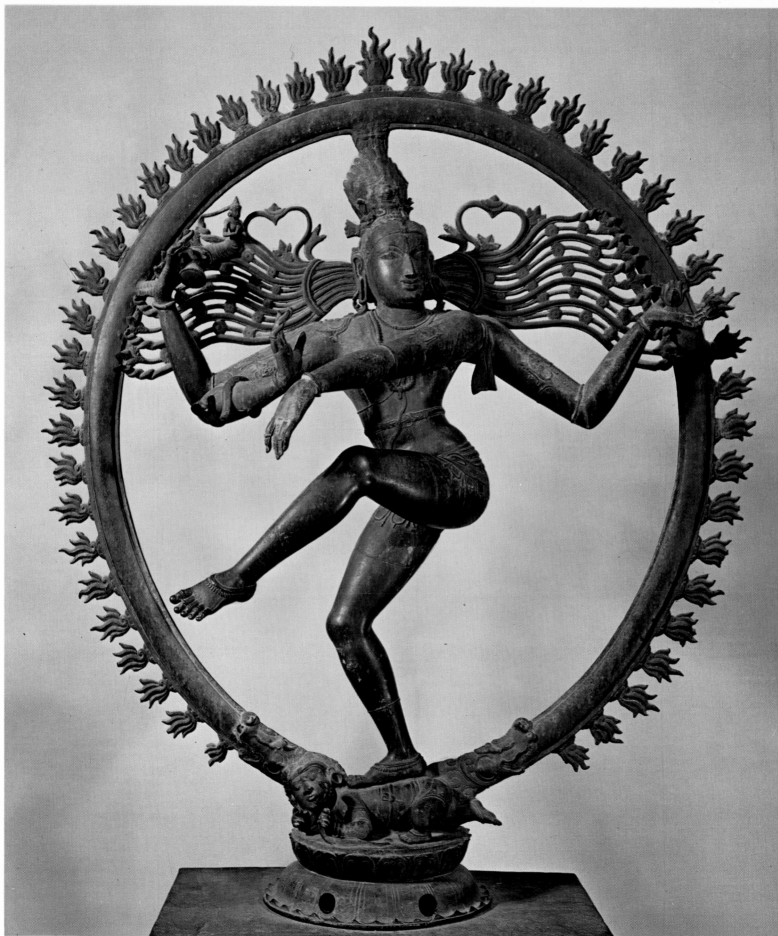

Shiva dancing.

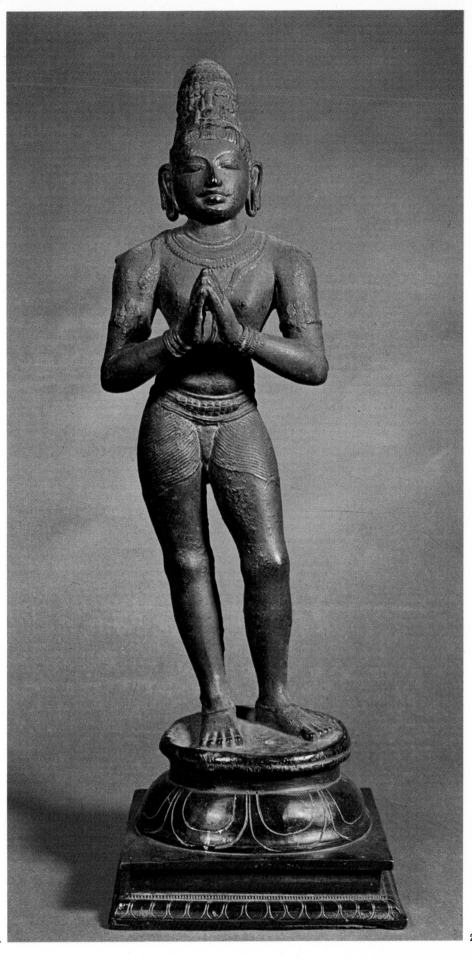

Chandikeshvara.

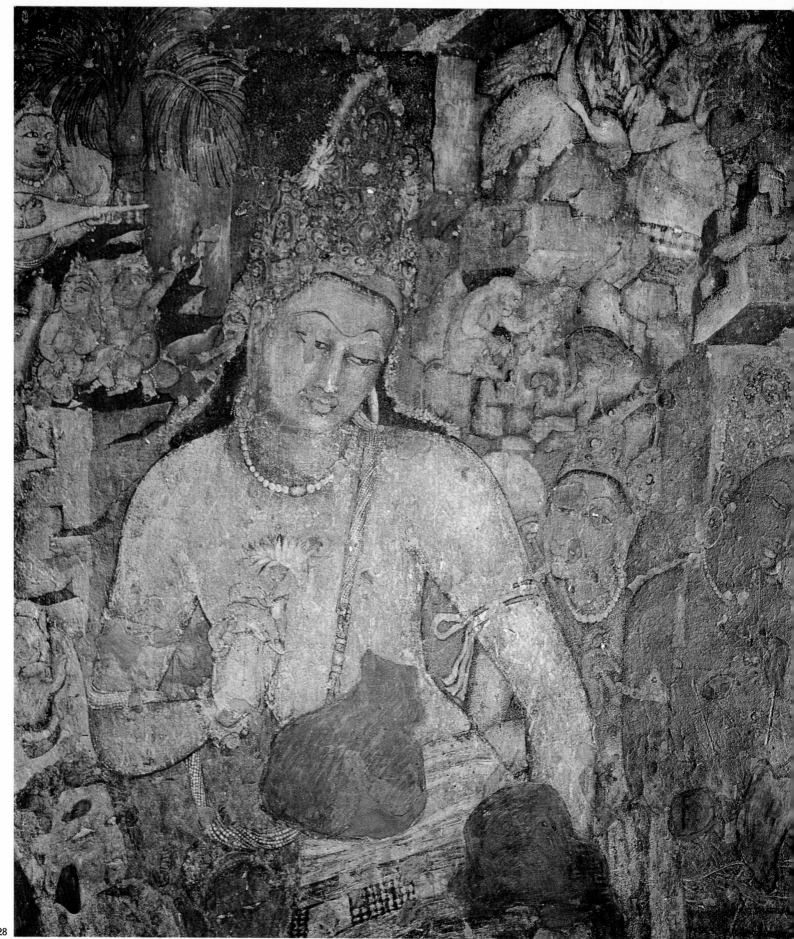

Fresco painting decorating Cave 1 at Ajanta.

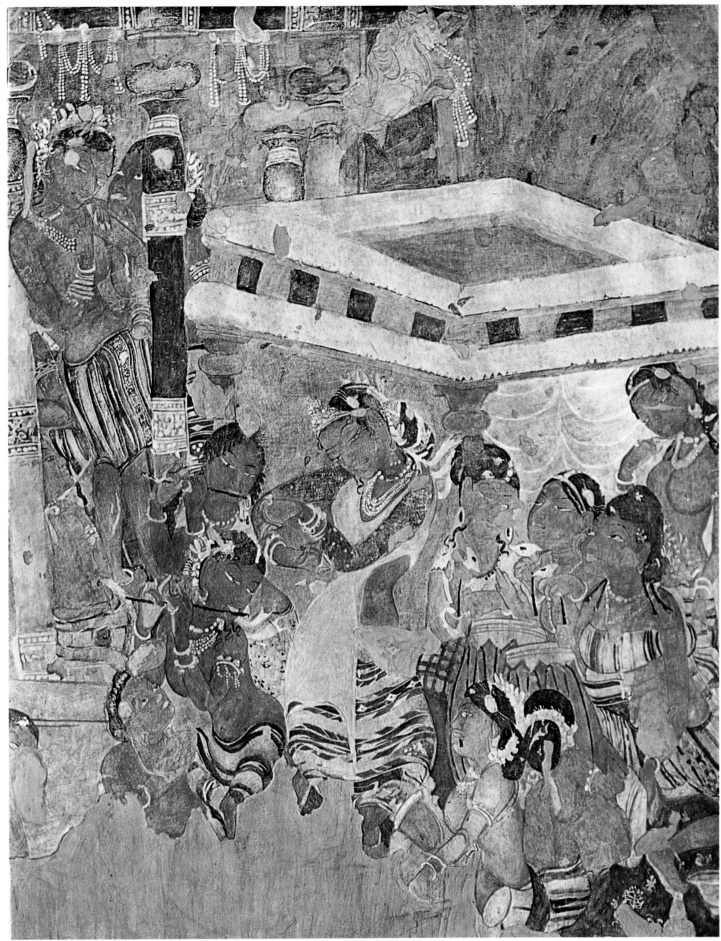

29

Girl Dancers and Musicians.

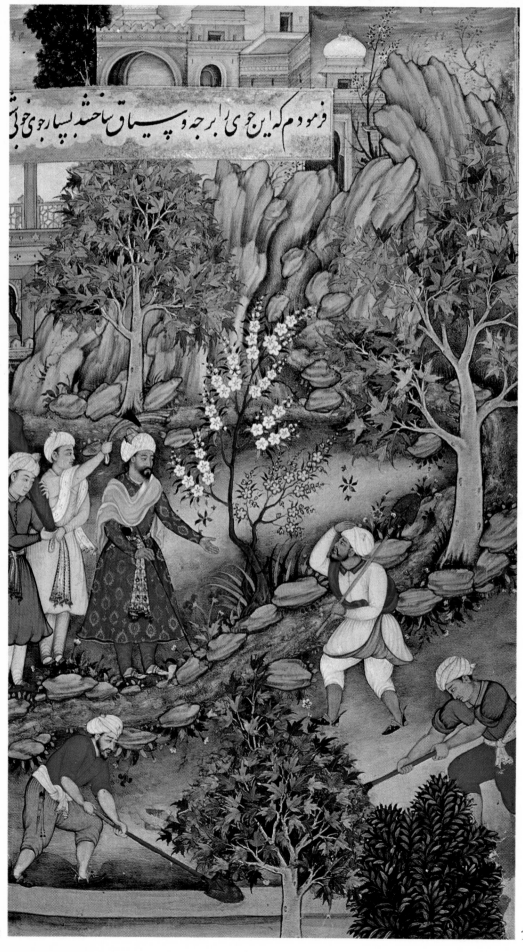

The emperor Bābur inspecting a garden.

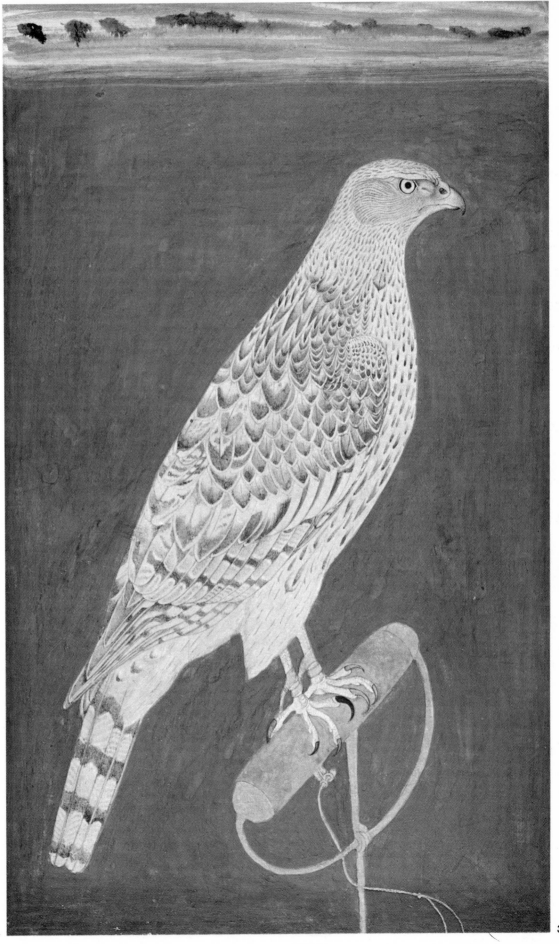

Falcon.

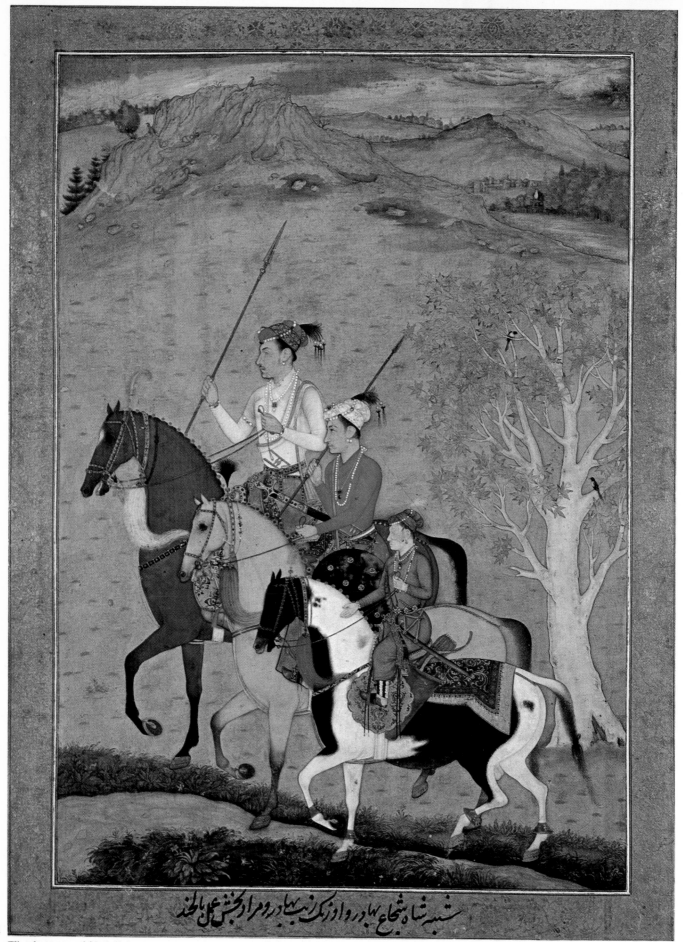

شبیه شاه شجاع بهادر و اورنگ زیب بهادر و مراد بخش عمل بالهند

The three sons of Shāh Jahān.

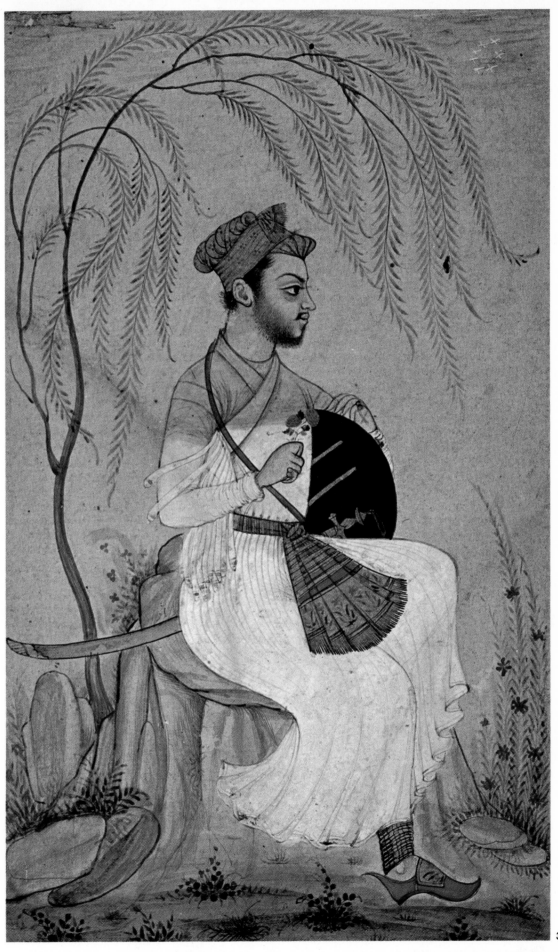

Portrait of a Prince.

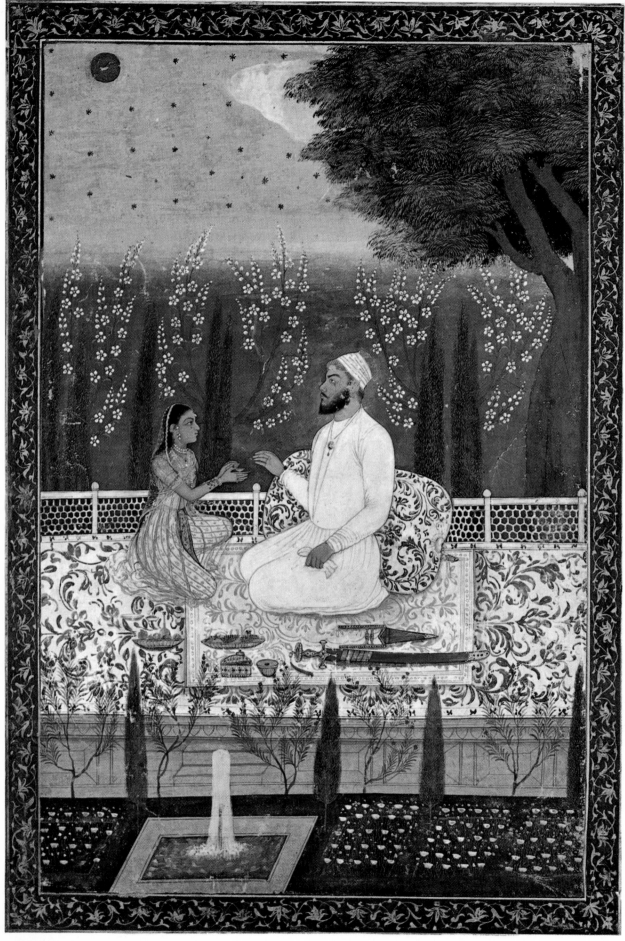

Couple on a terrace.

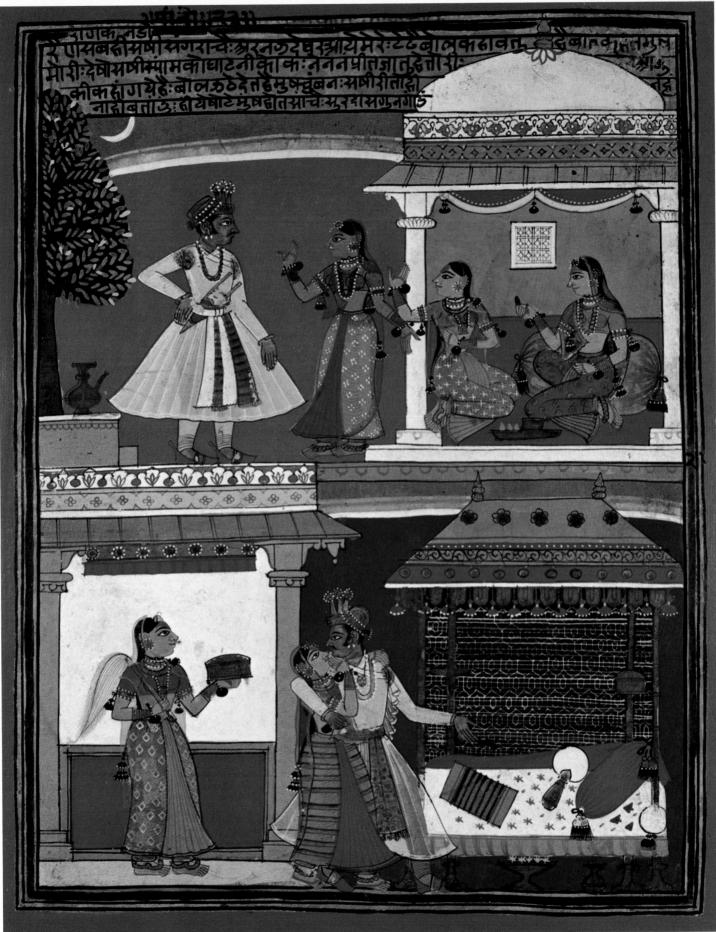

Krishna and Radhā.

37

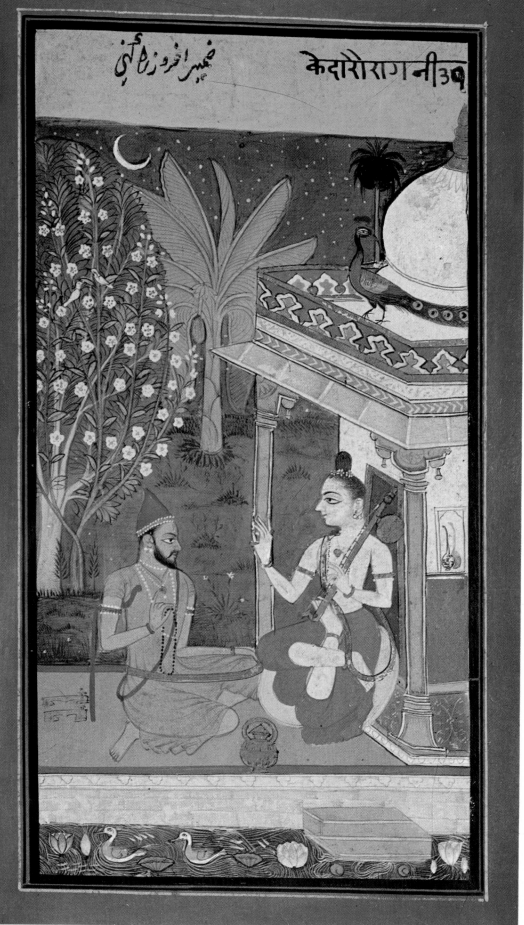

Kedara Ragini.

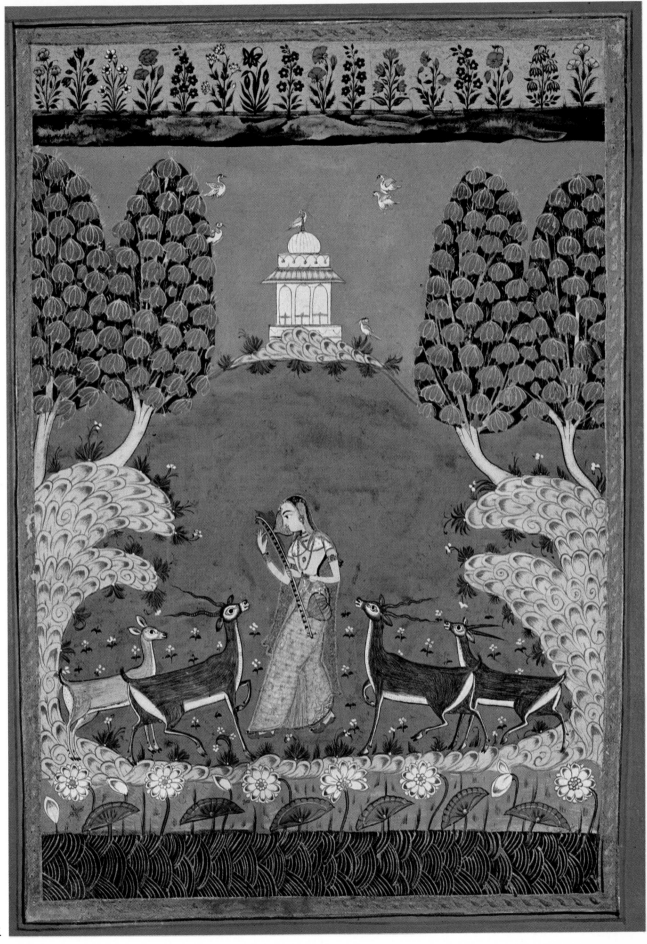

Todi Raginī.

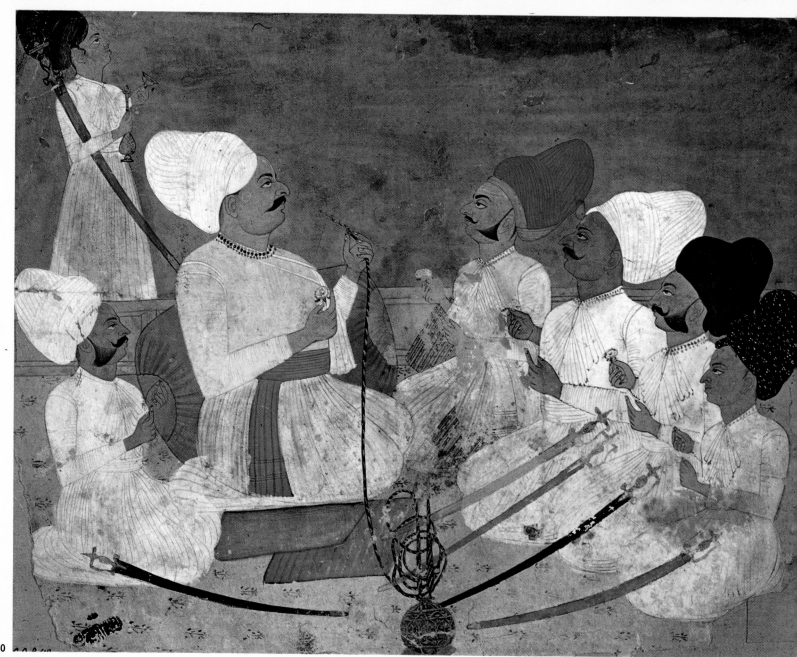

40

The Rāja Ajit Singh.

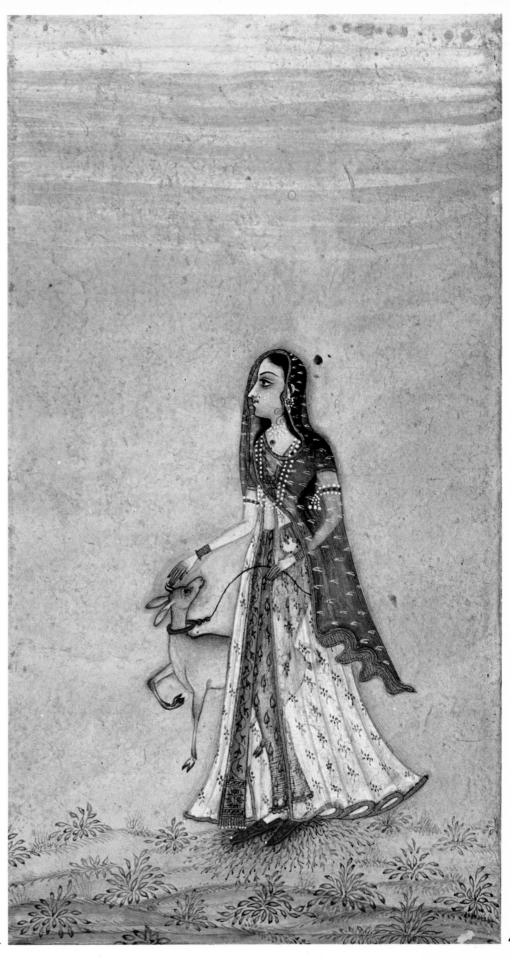

Queen and her buck.

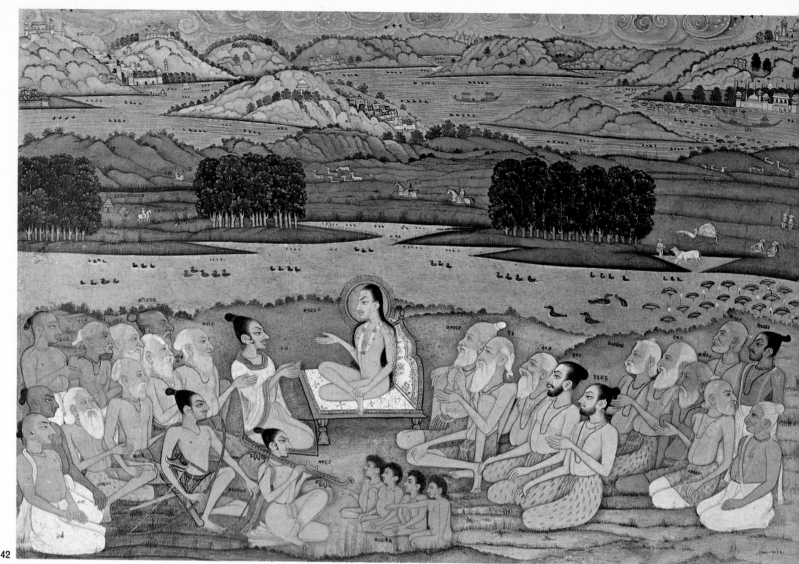

42

Muni Shri Sukdevji preaching to the Rāja Parikshit, urging him to renounce his throne.

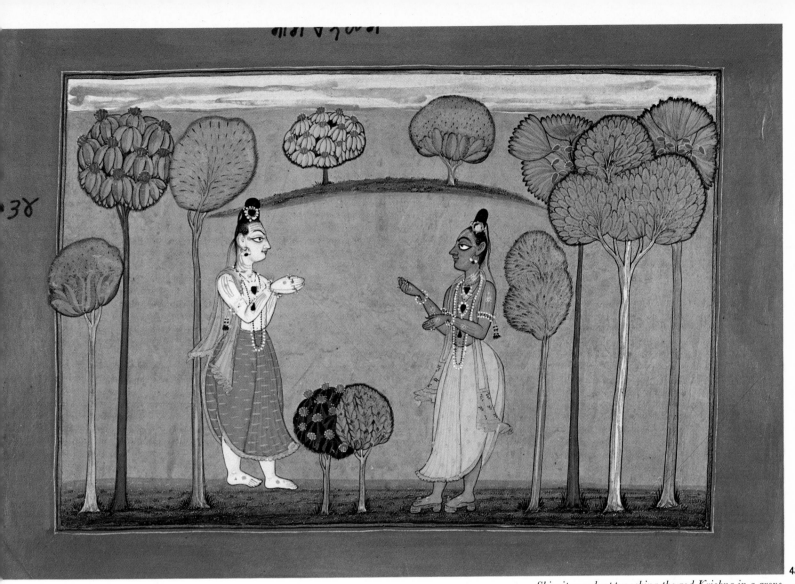

Shivaite monk approaching the god Krishna in a grove.

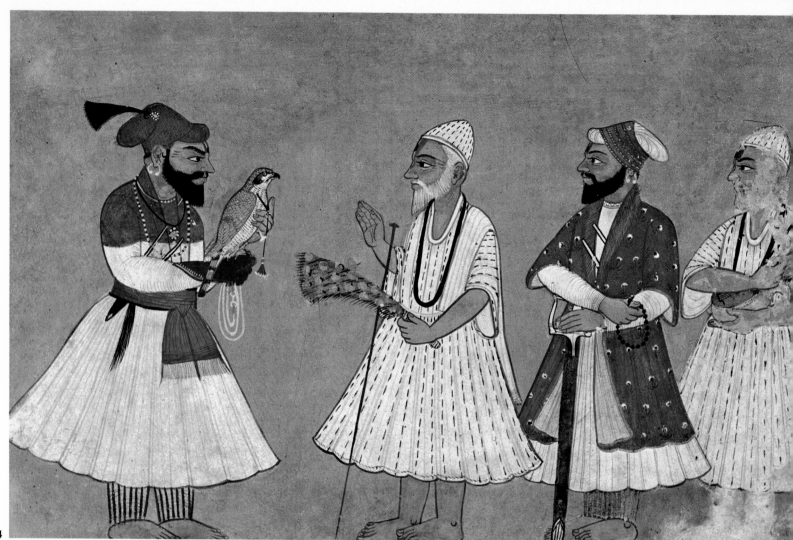

44

Nobles and dervishes.

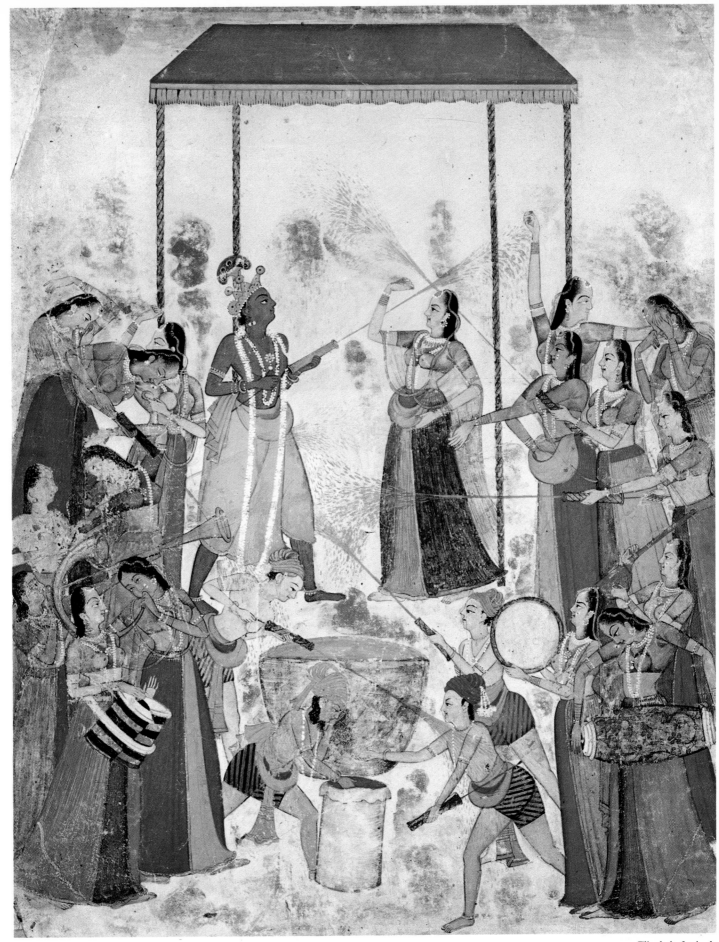

45

The holī festival.

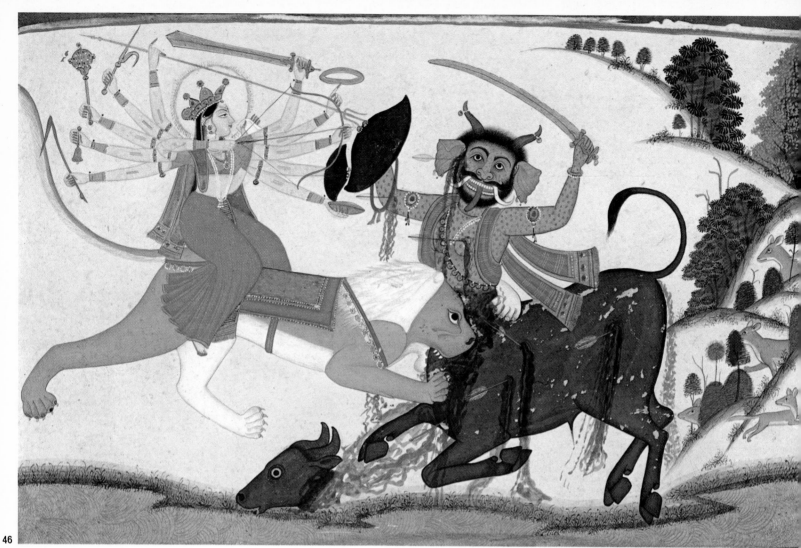

46
Durgā slaying the demon Mahishāsura.

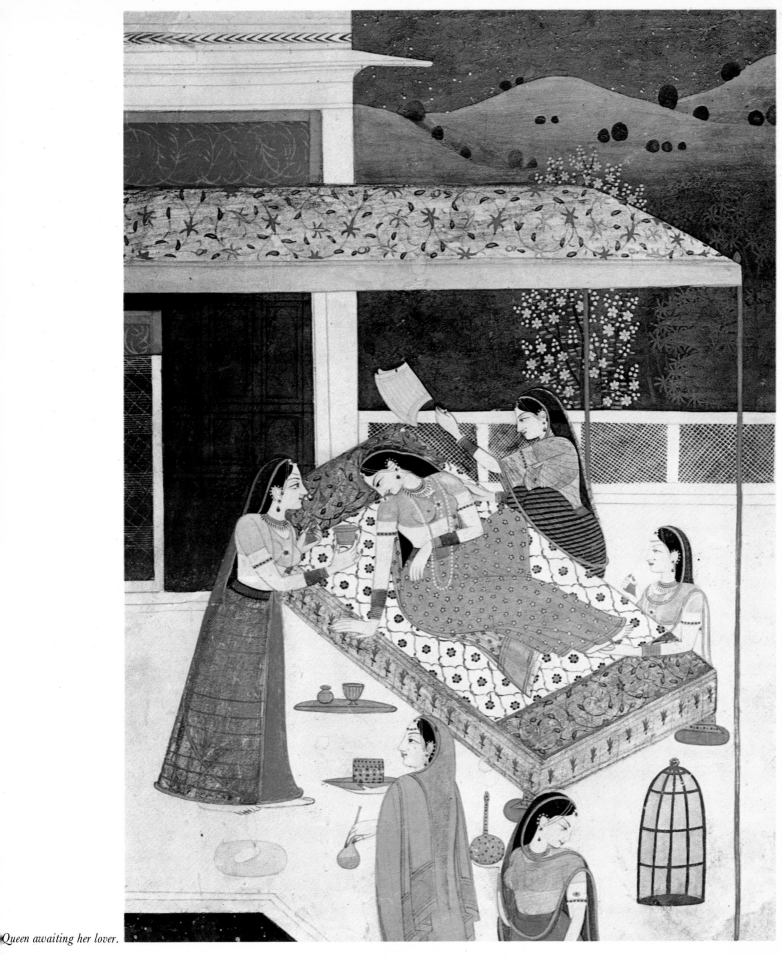

Queen awaiting her lover.

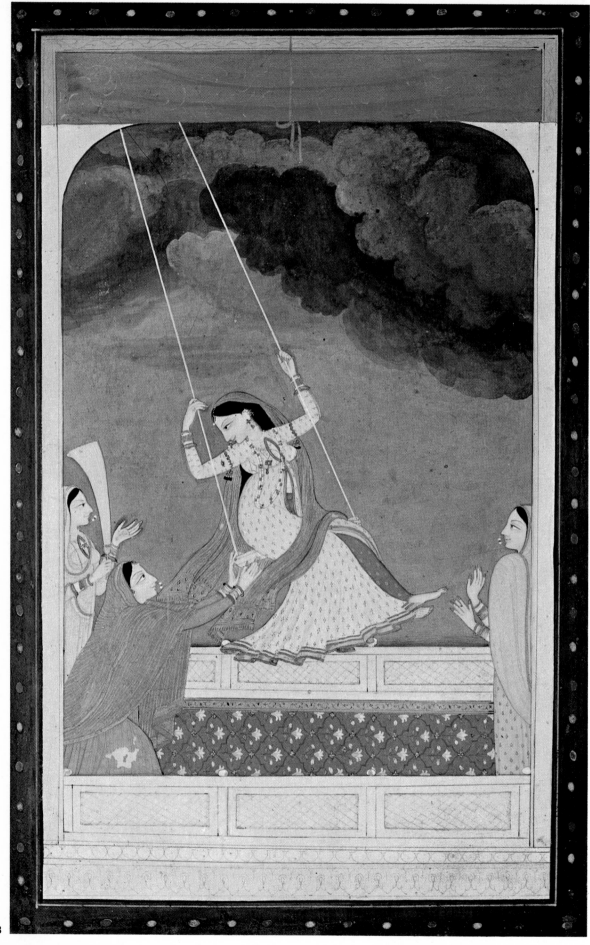

The swing.